This book belongs to:

Wonderful Fairy Homes

Thank you so much for purchasing this book! I hope you will love it. Please tag us when sharing your colored images on social media @Papernzendesigns

COLORING TIPS

• Use a blank sheet of paper behind each page to prevent bleeding.
• Use the test page provided to check your colors.
• Use linework as a guide and be creative to add more elements.

I am a small independent publisher from USA and love designing these books for you. If you are enjoying this book, it would mean a world to me if you can leave a review on Amazon.

Check out other amazing books from Papernzen Designs.
Happy Coloring!

Test colors here:

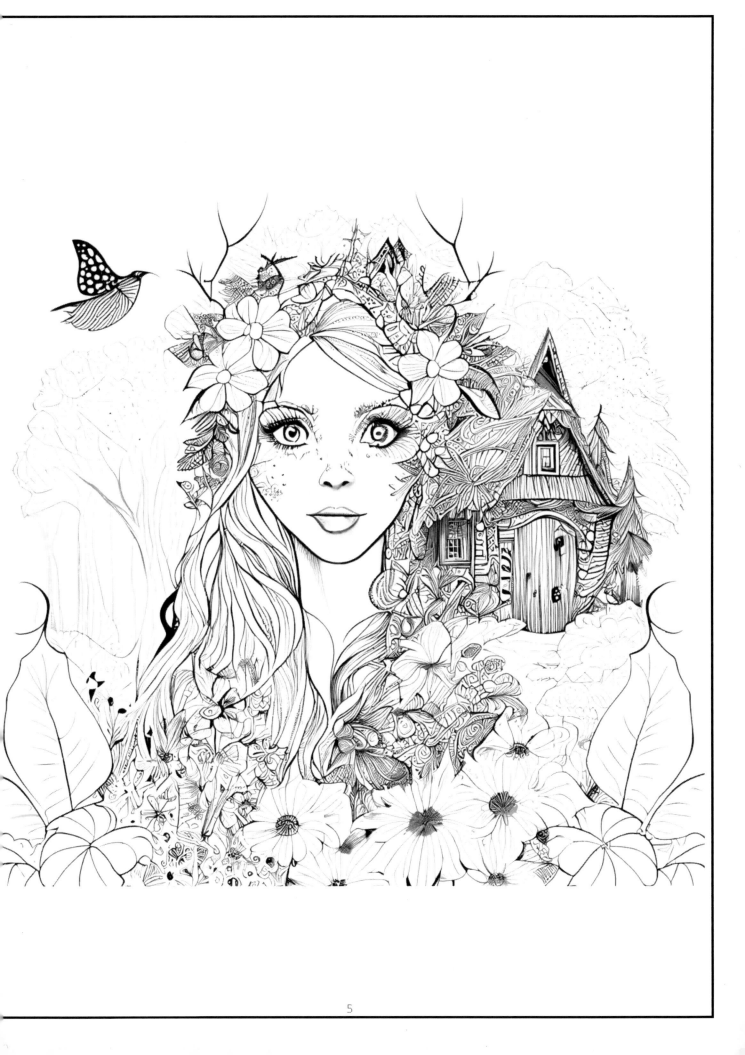

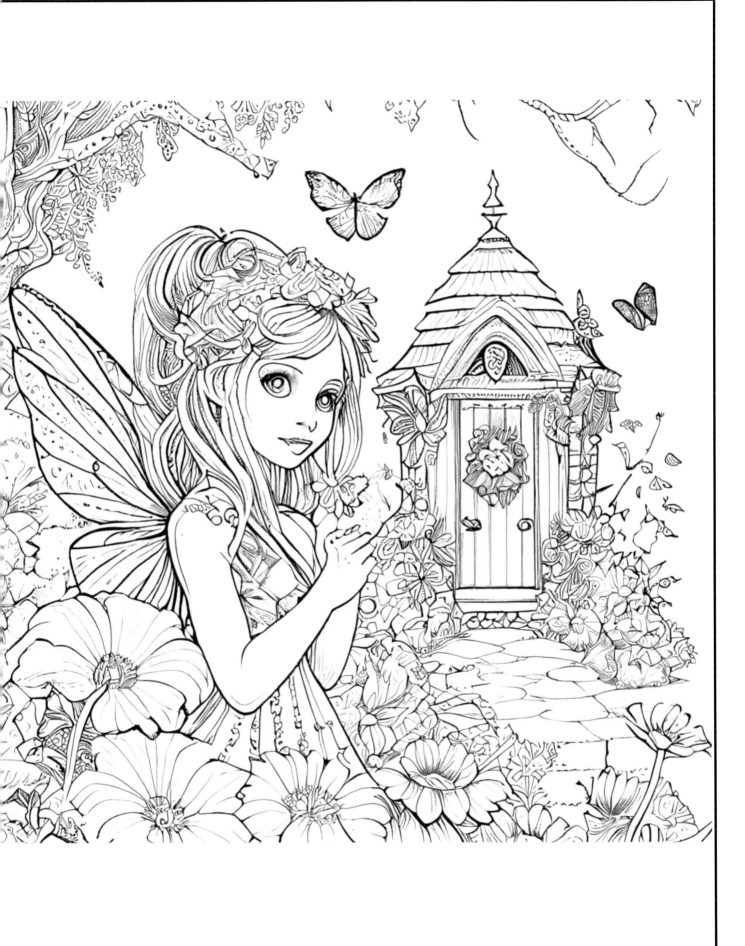

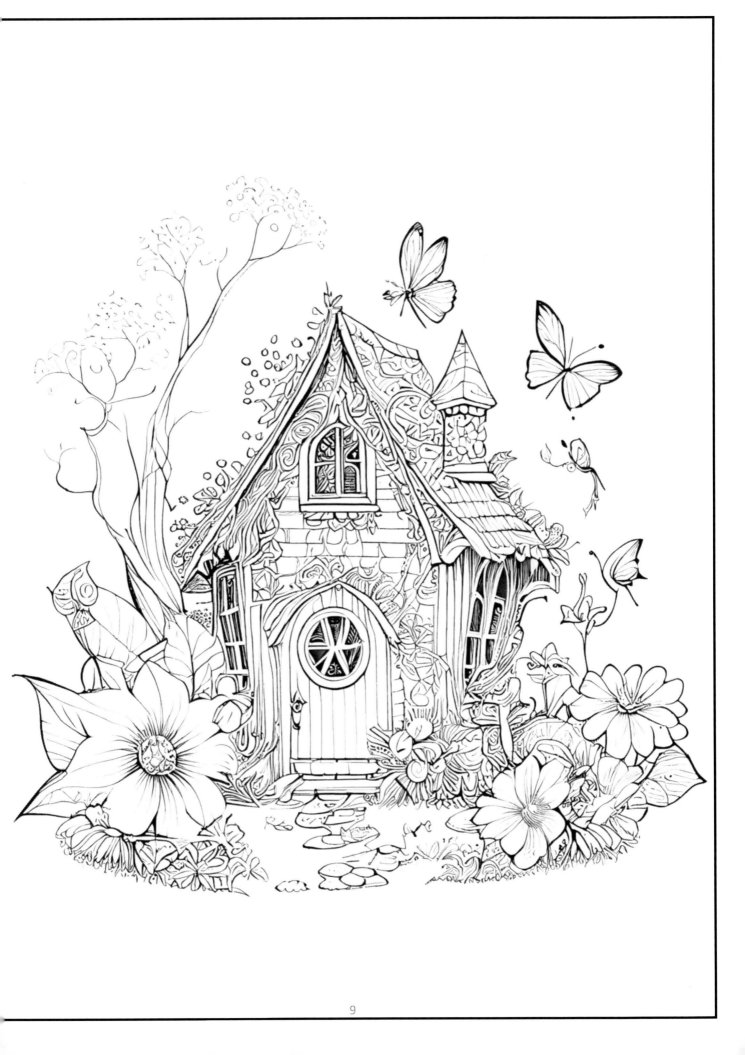

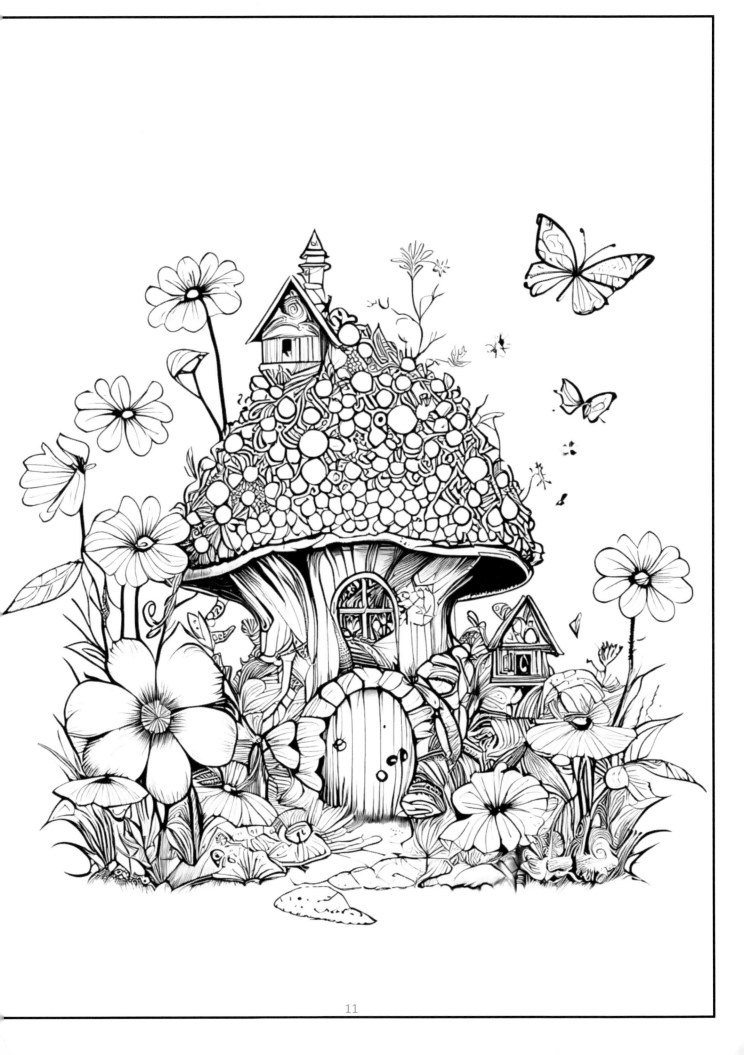

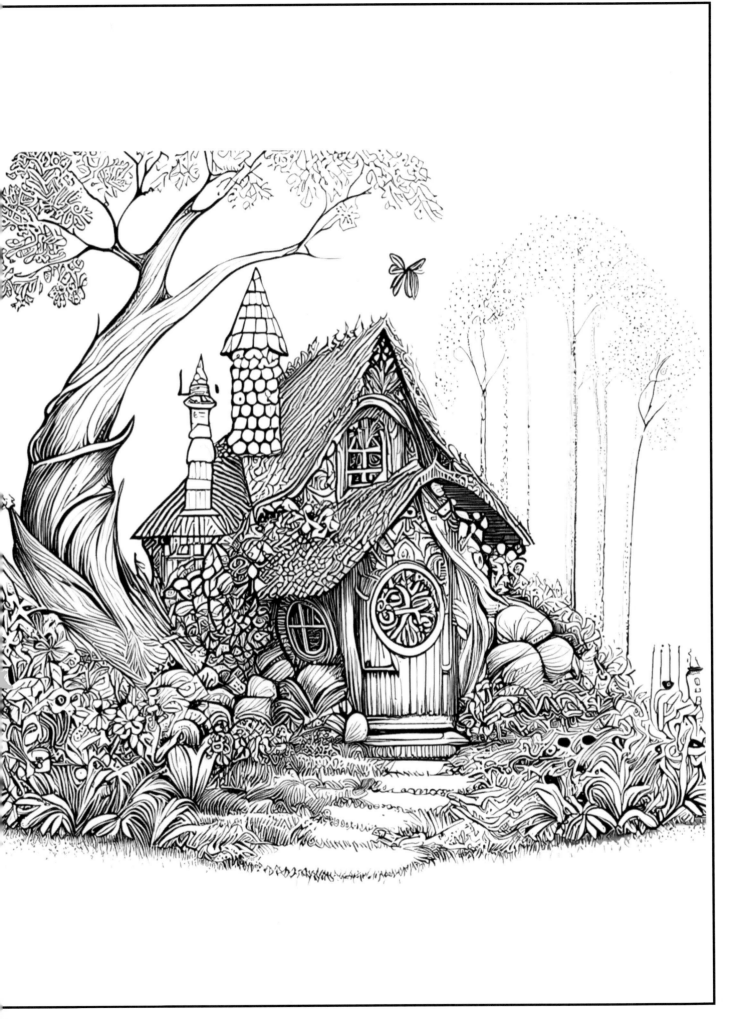

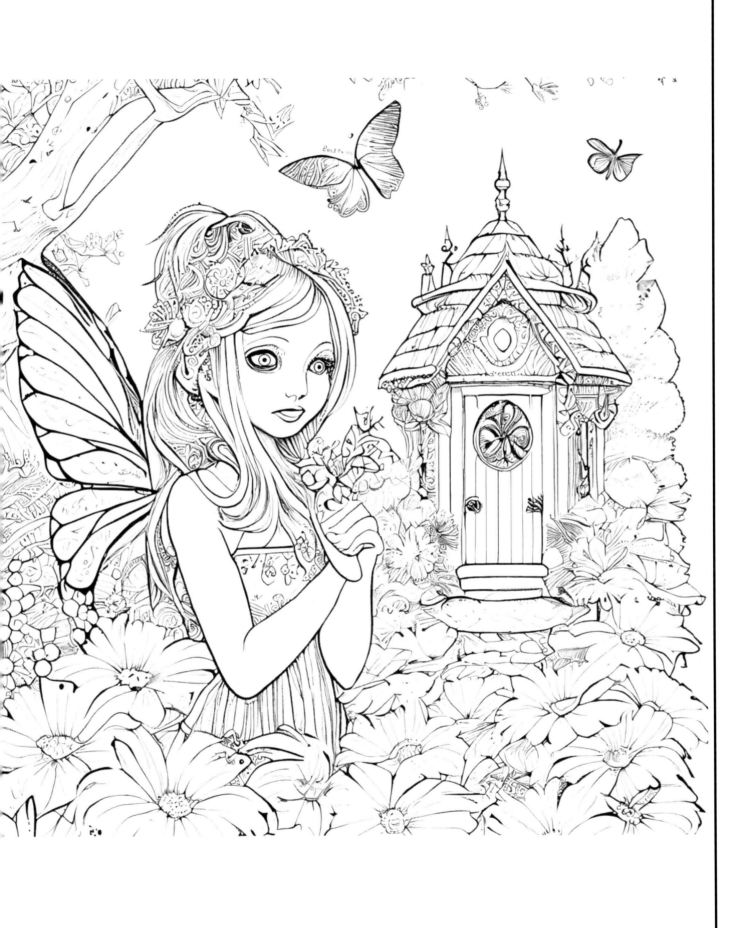

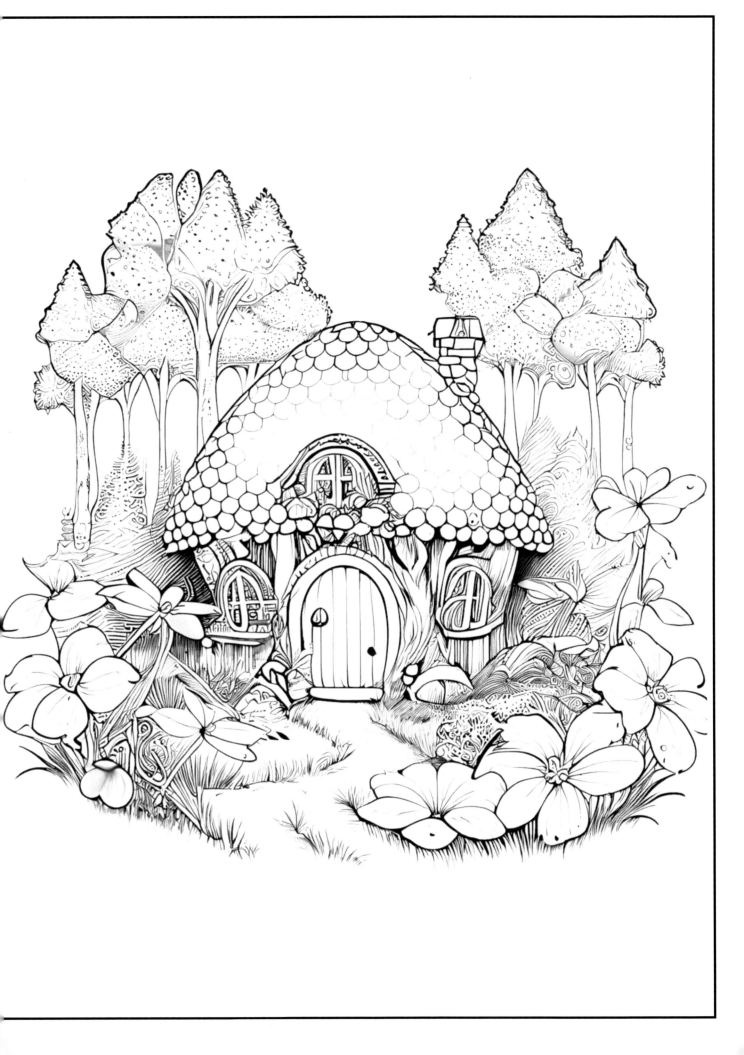

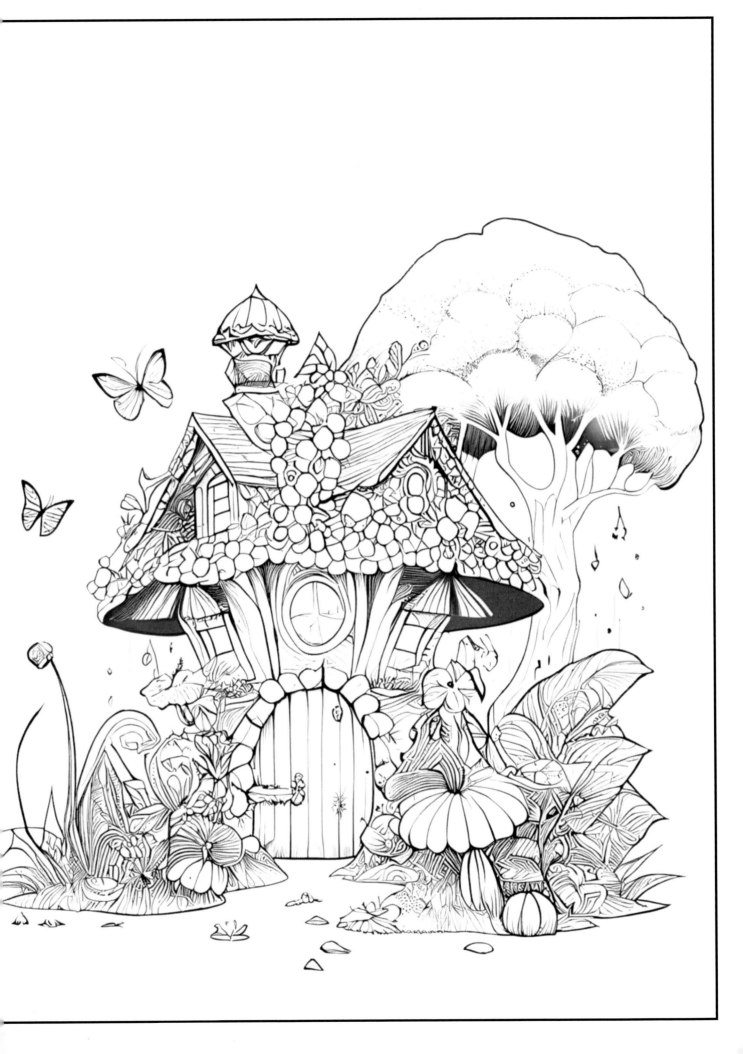

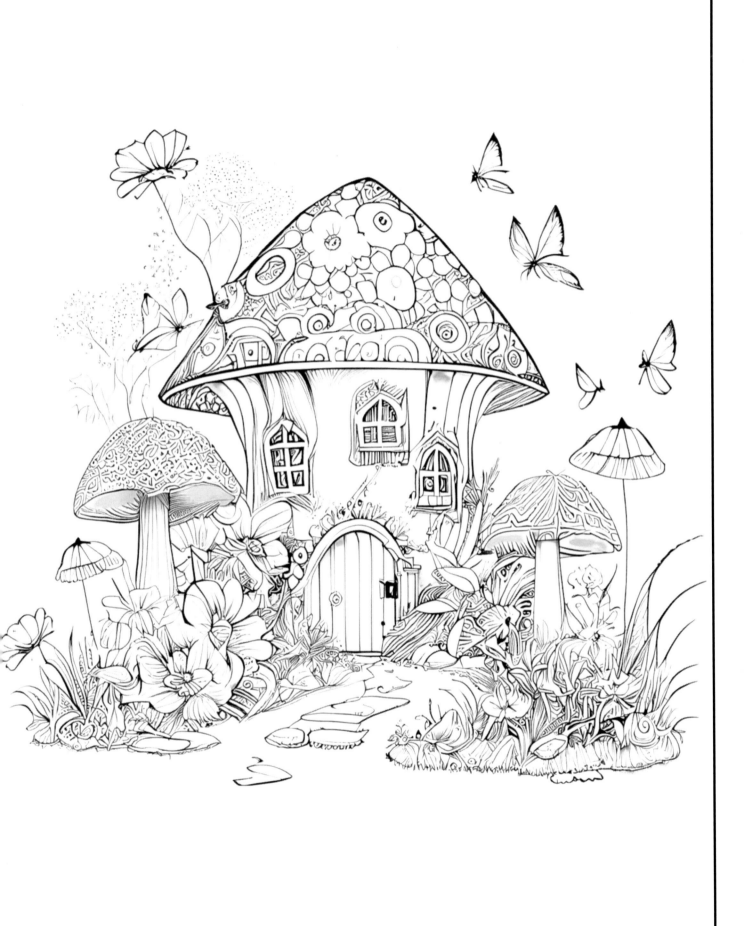

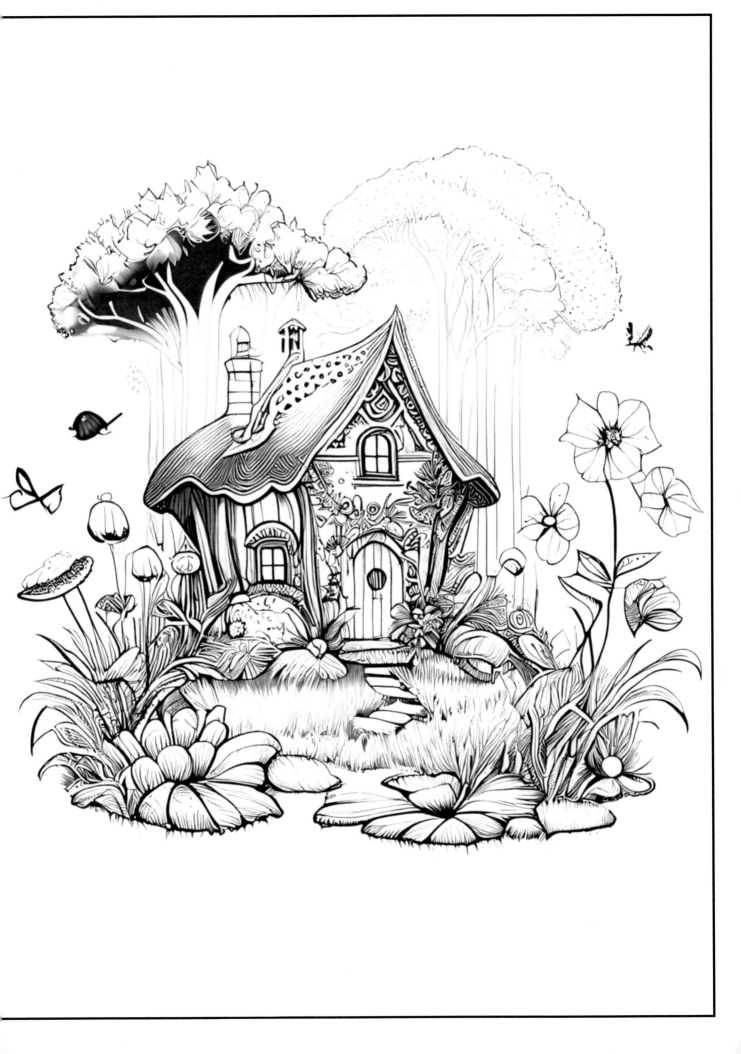

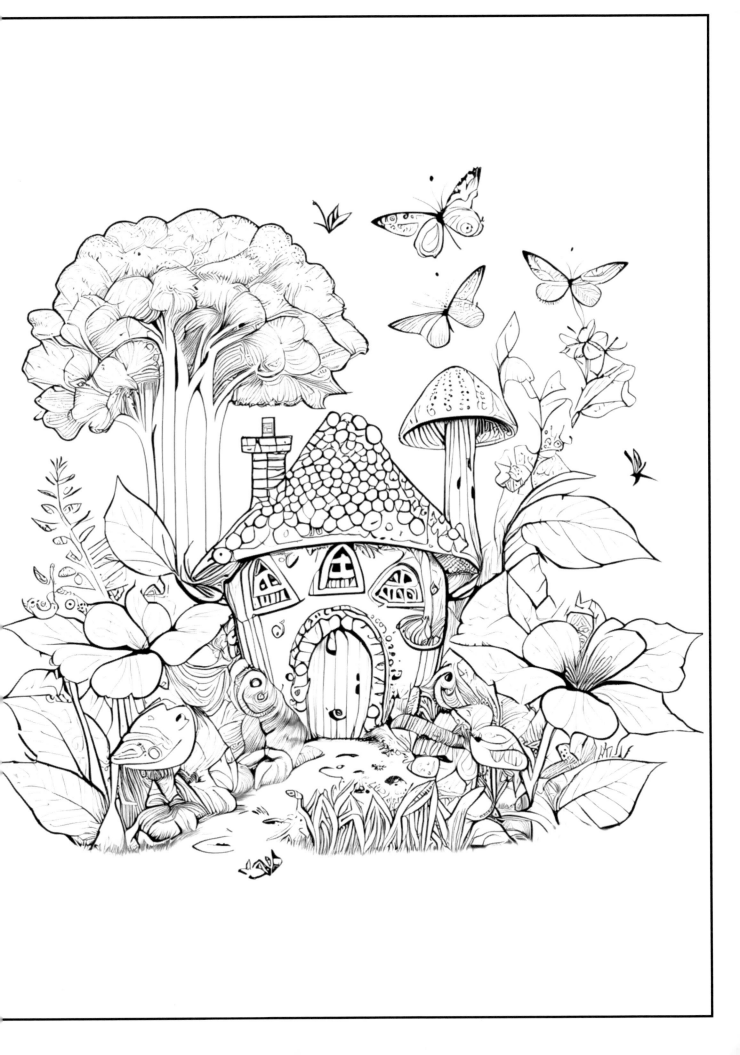

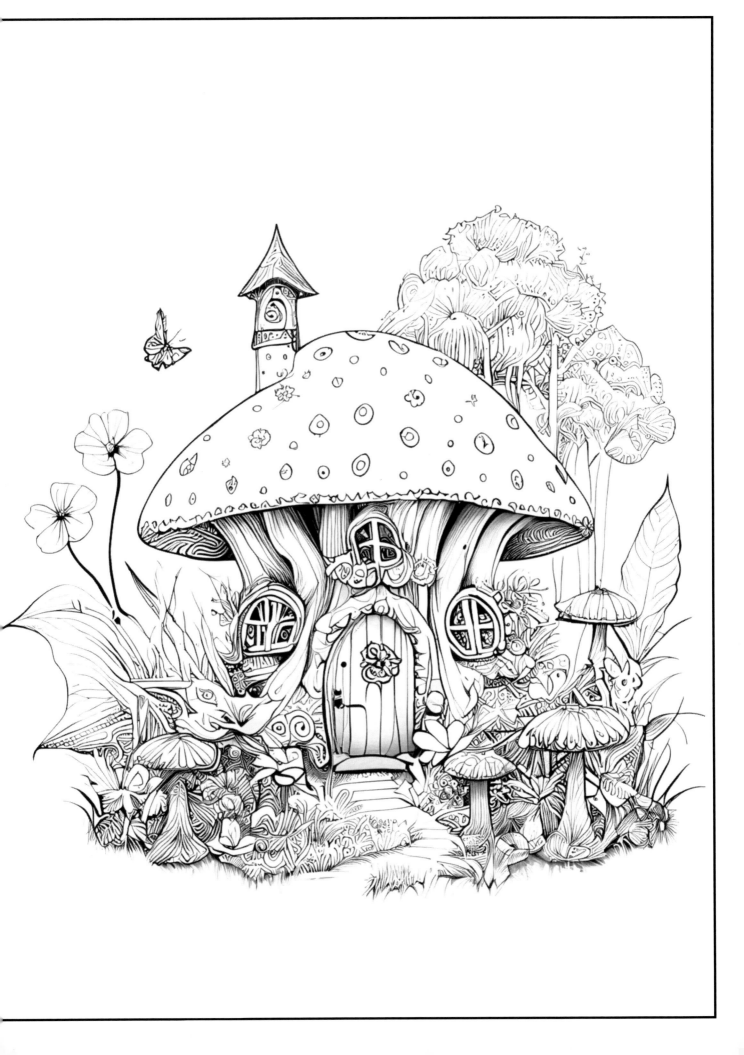

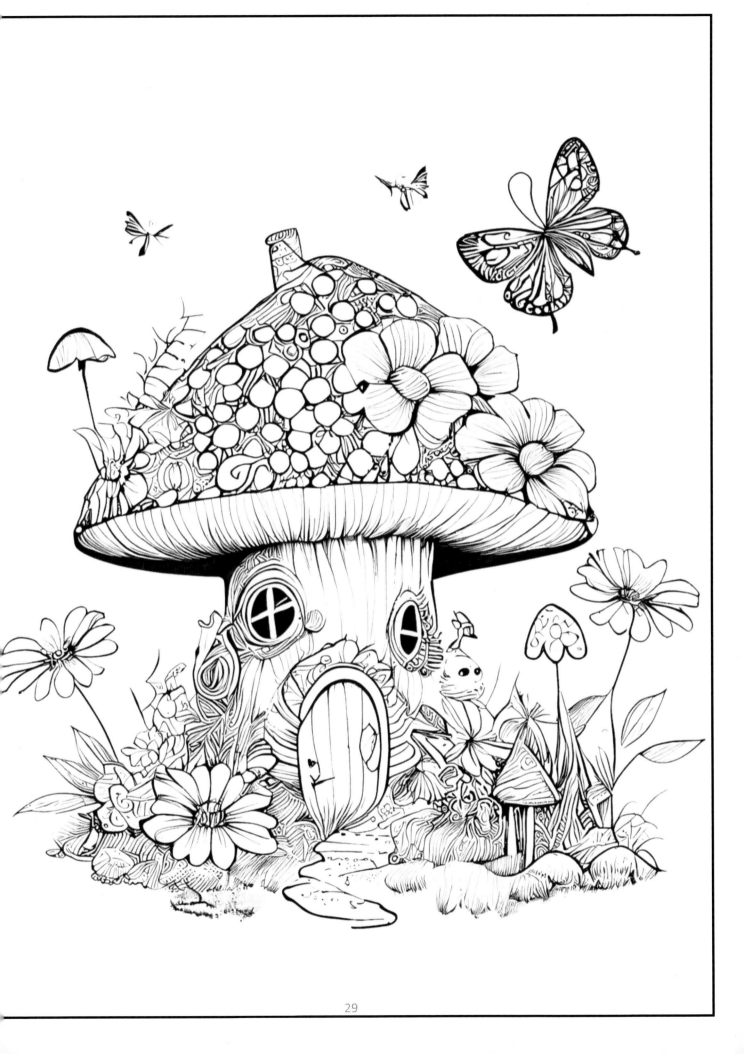

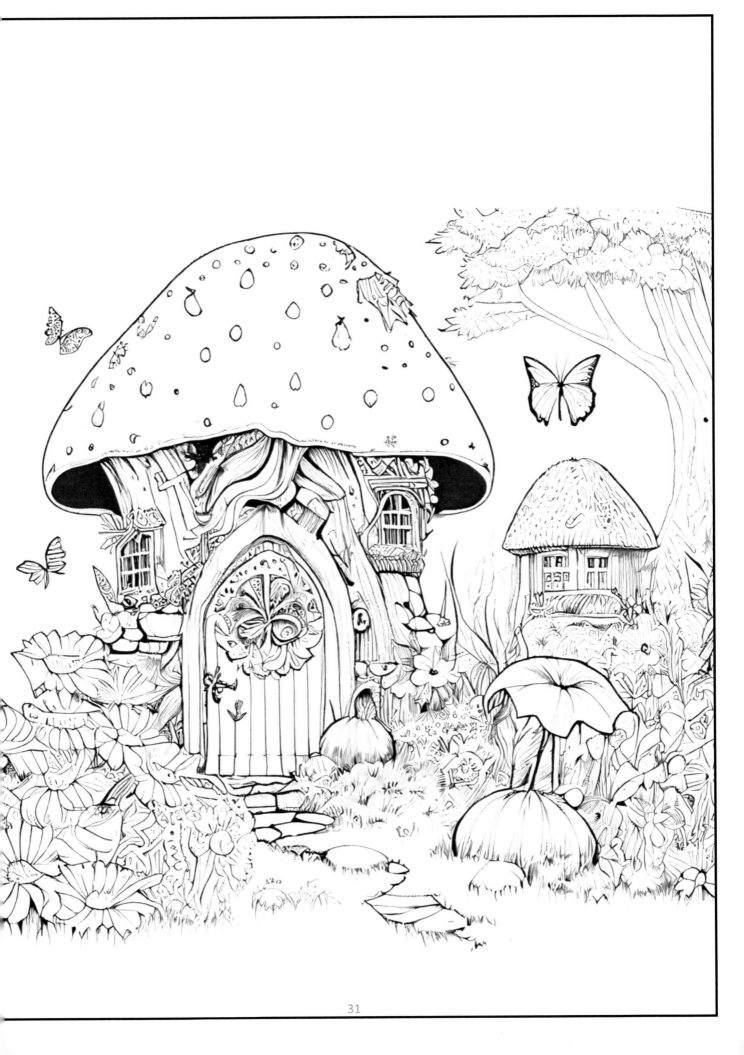

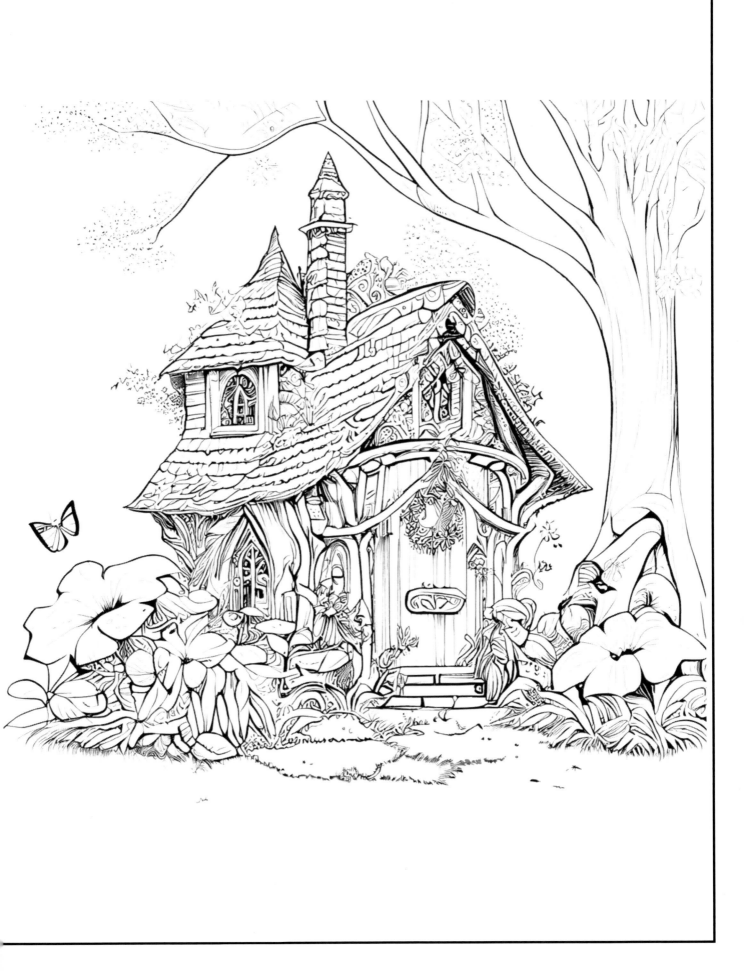

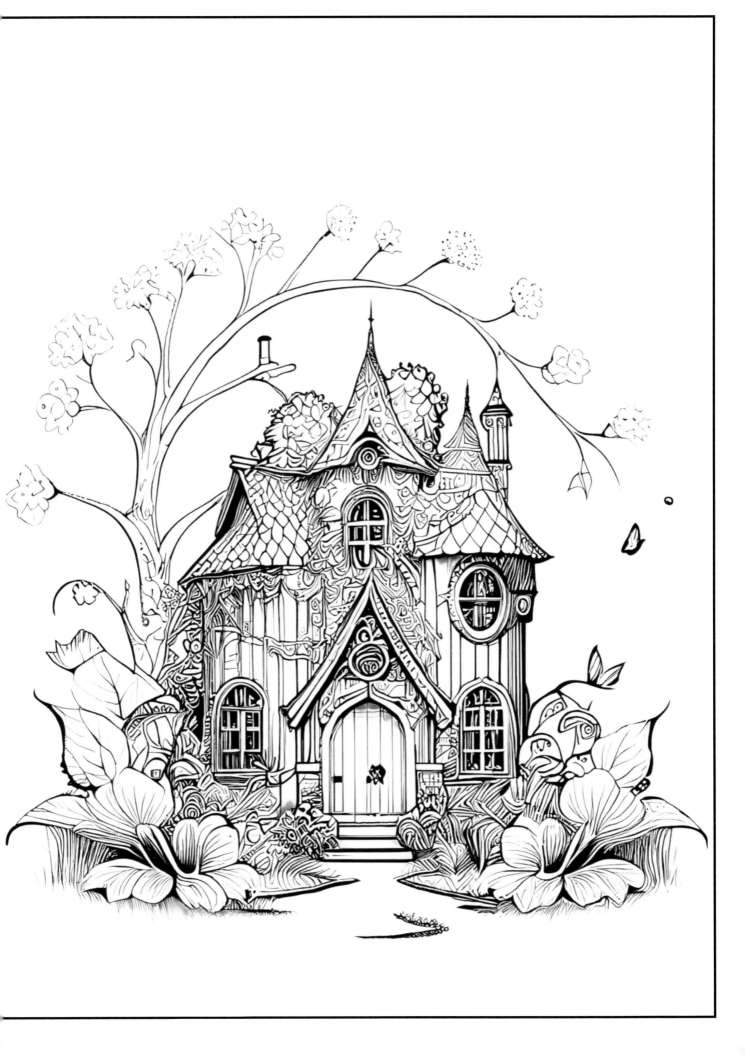

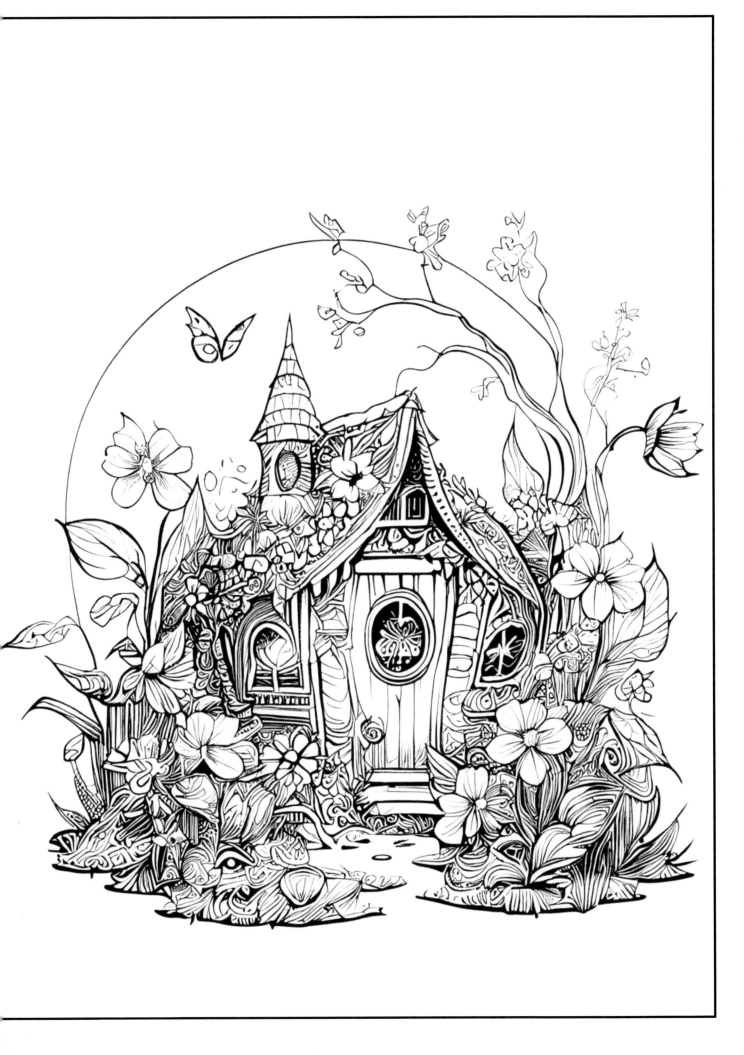

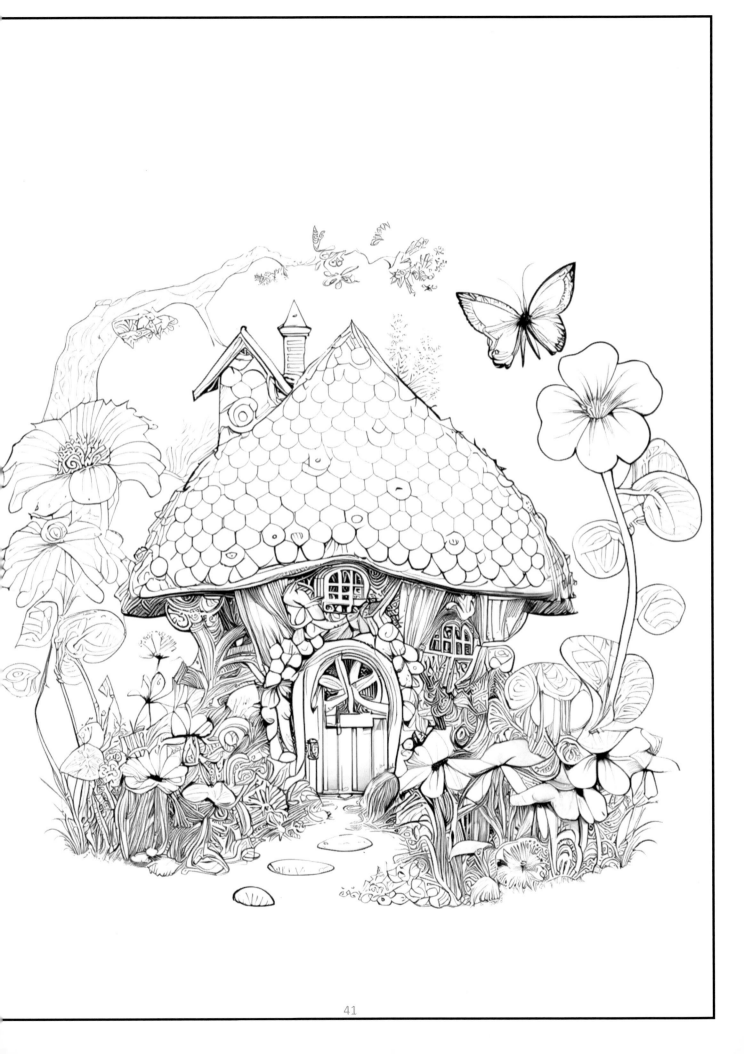

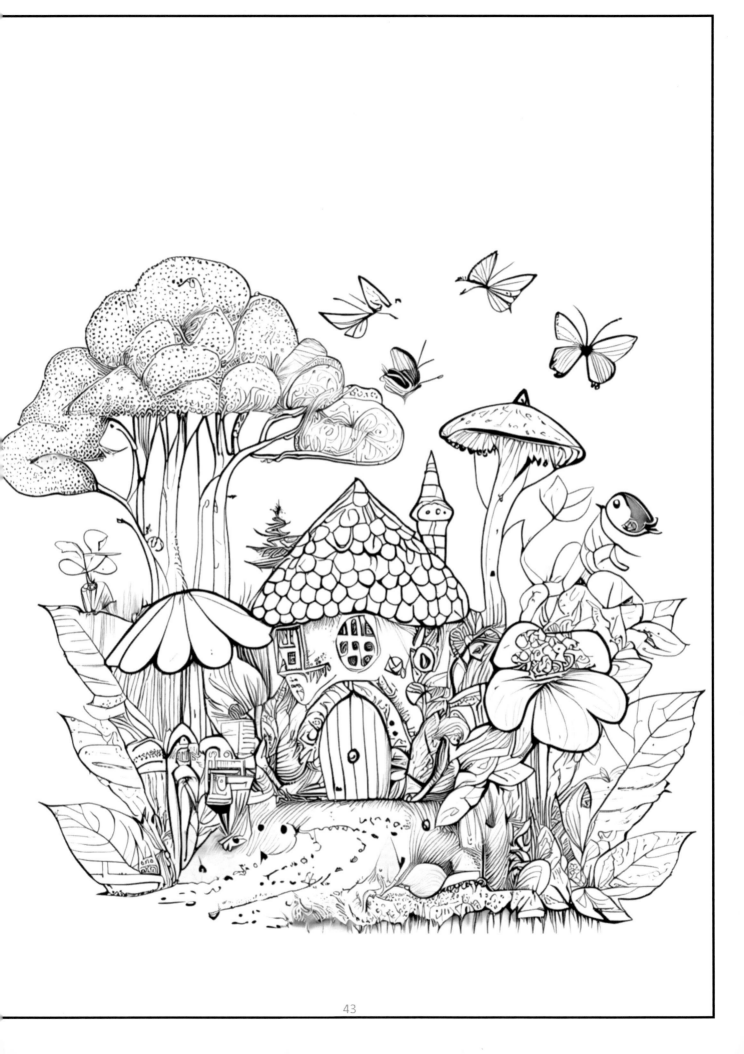

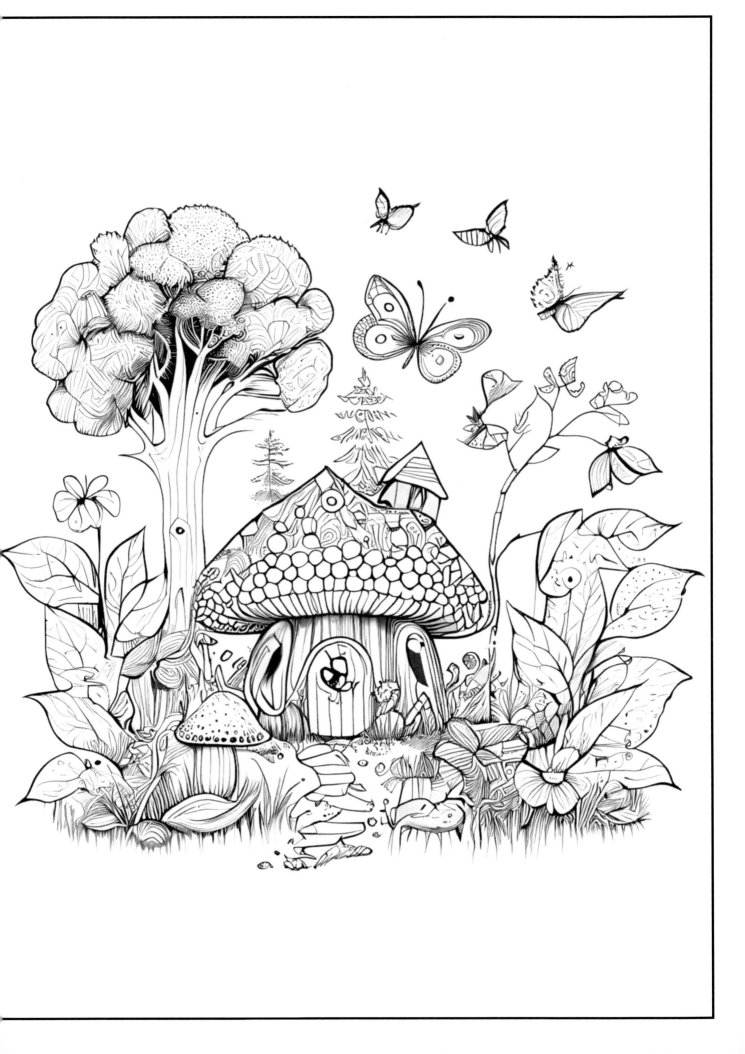

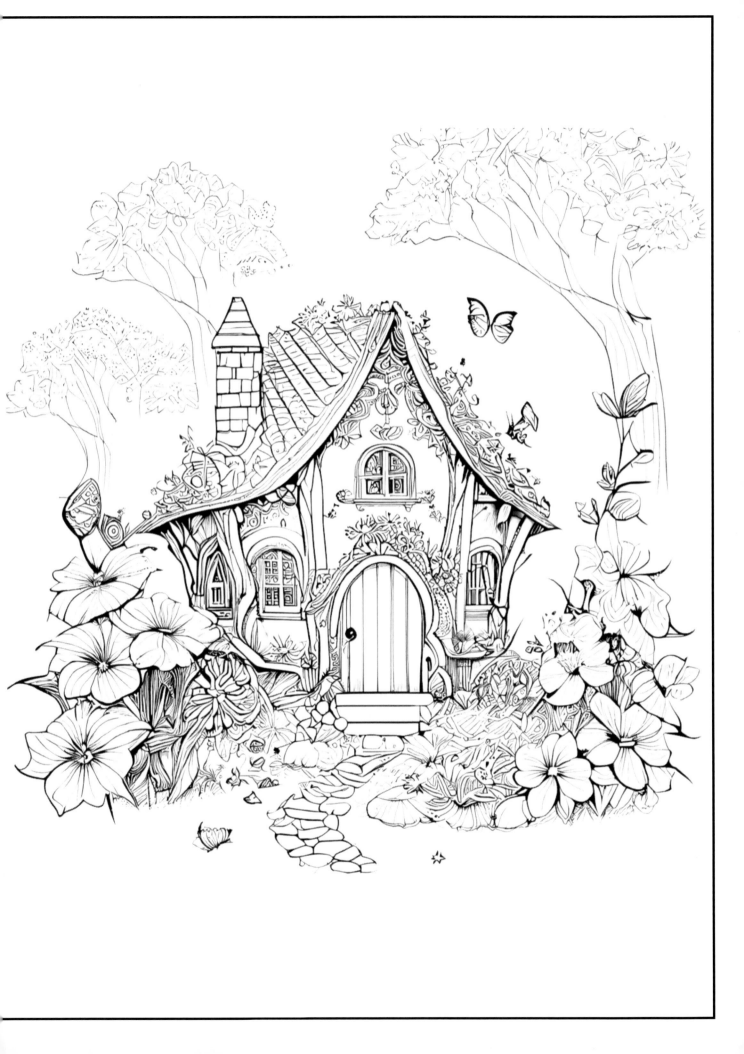

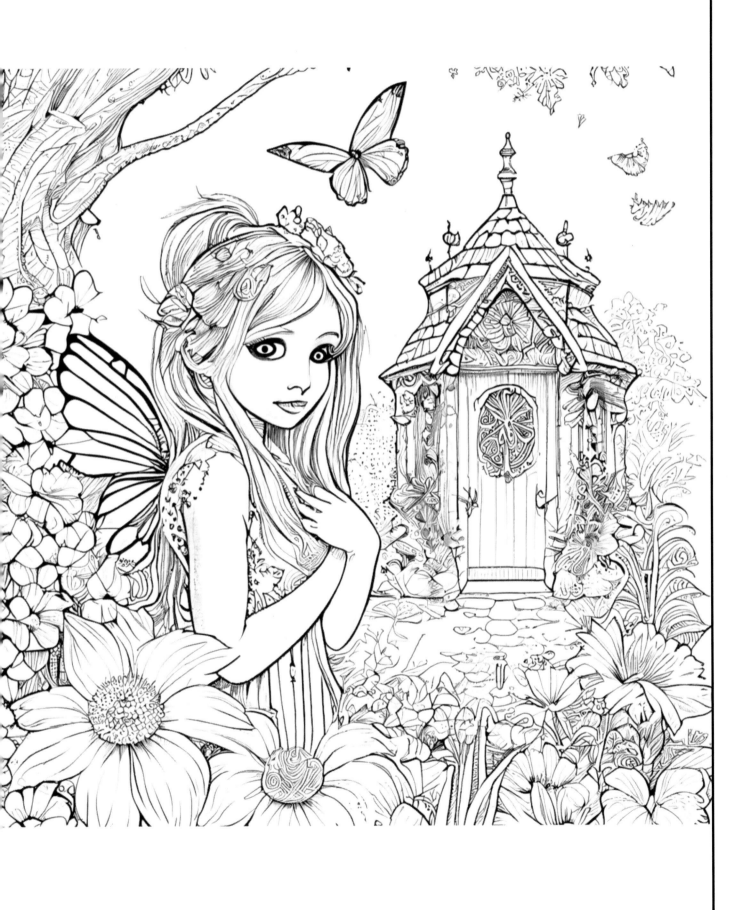

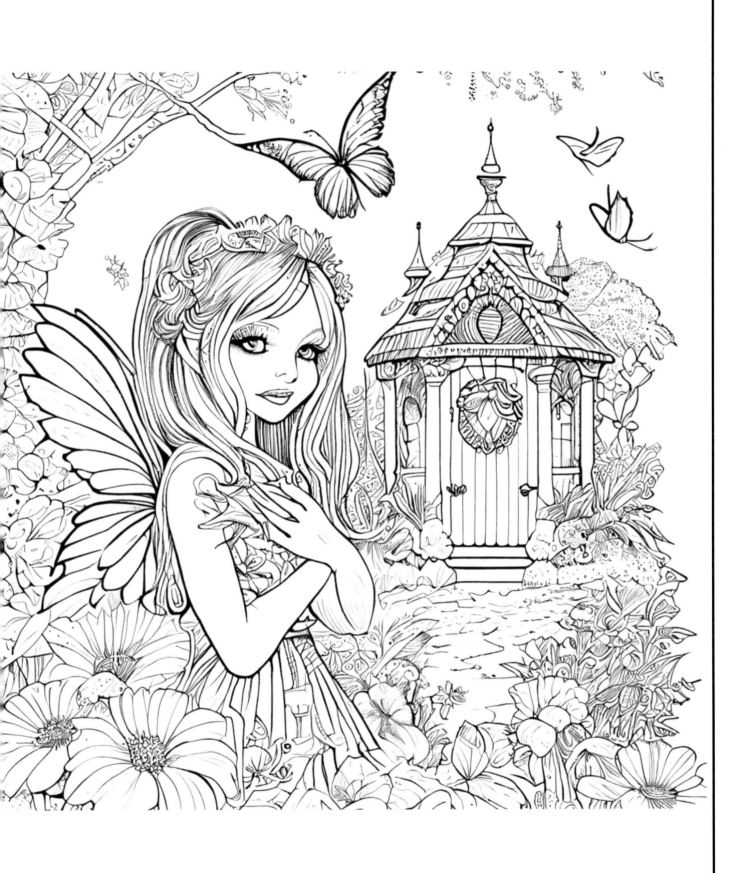

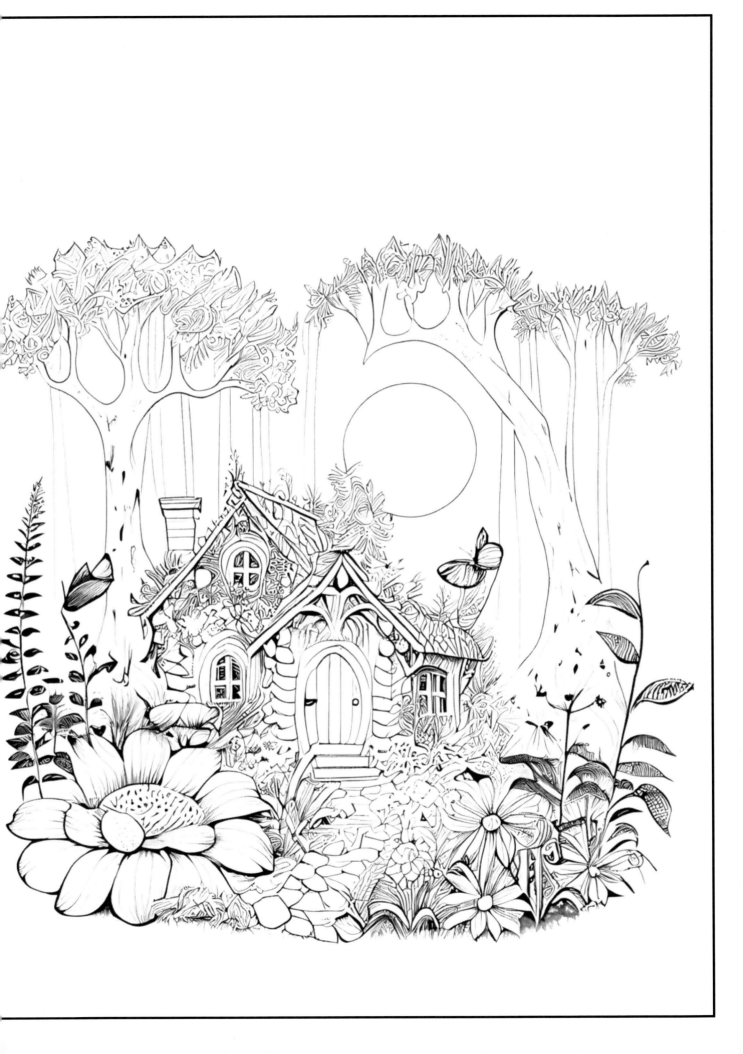

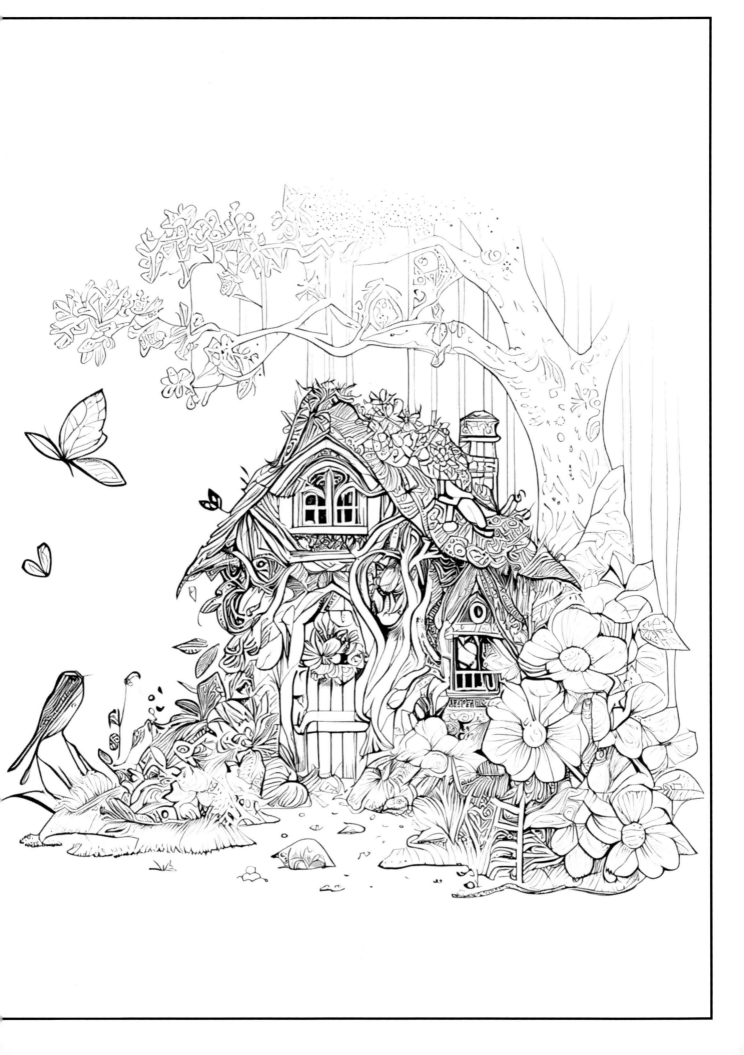

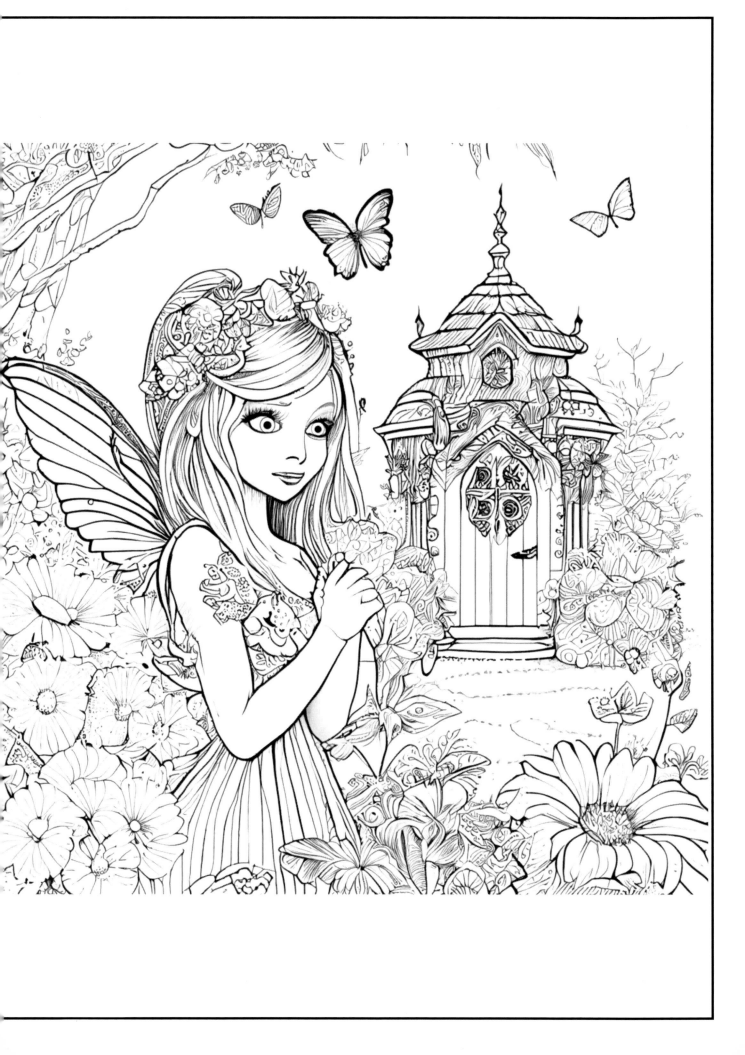

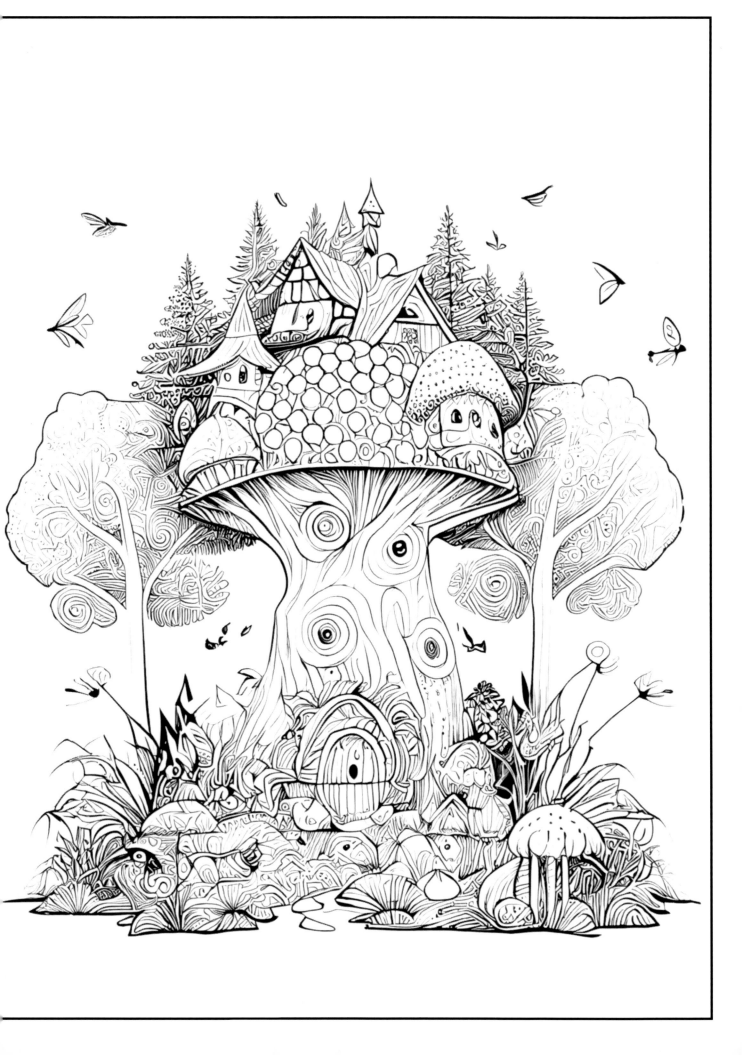

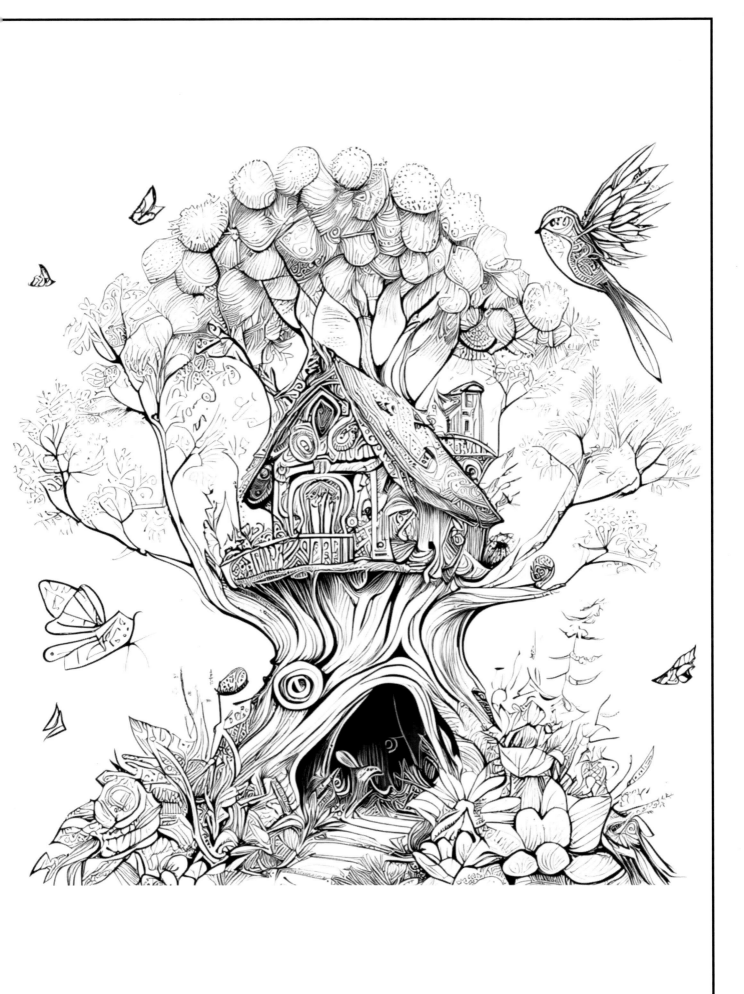

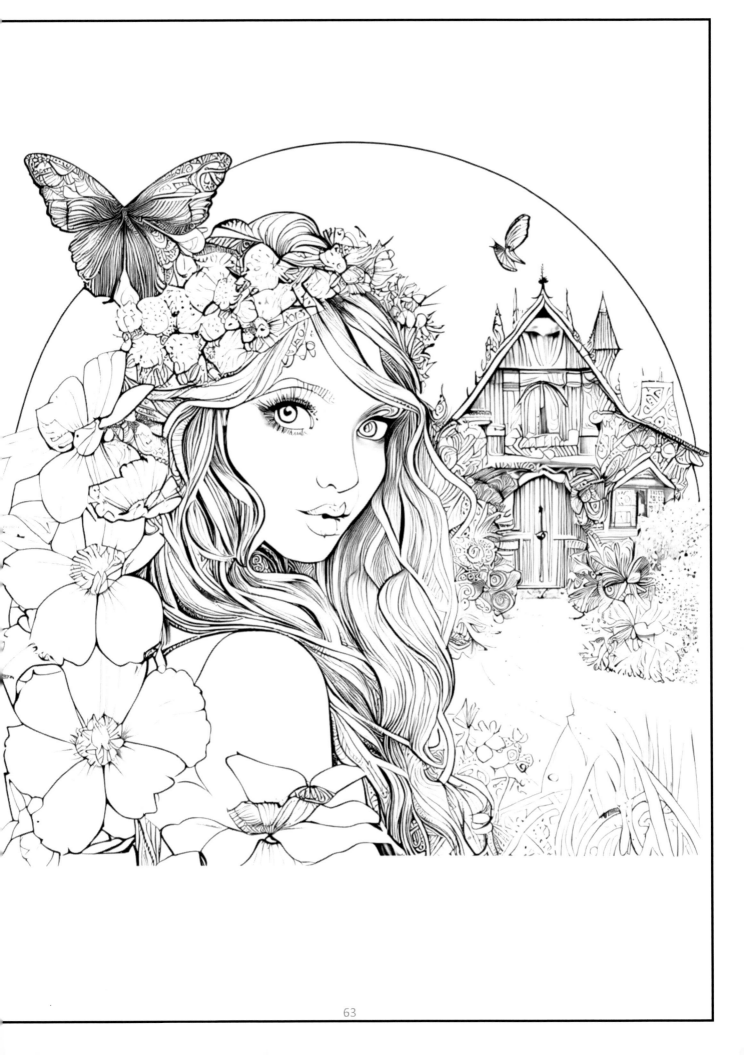

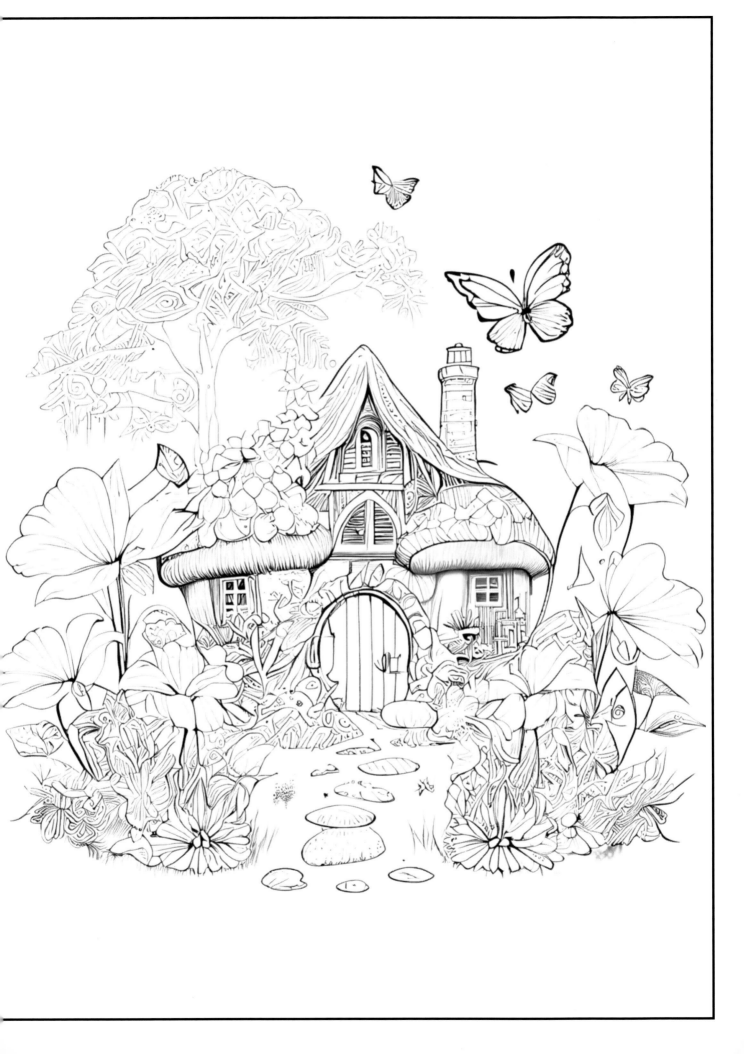

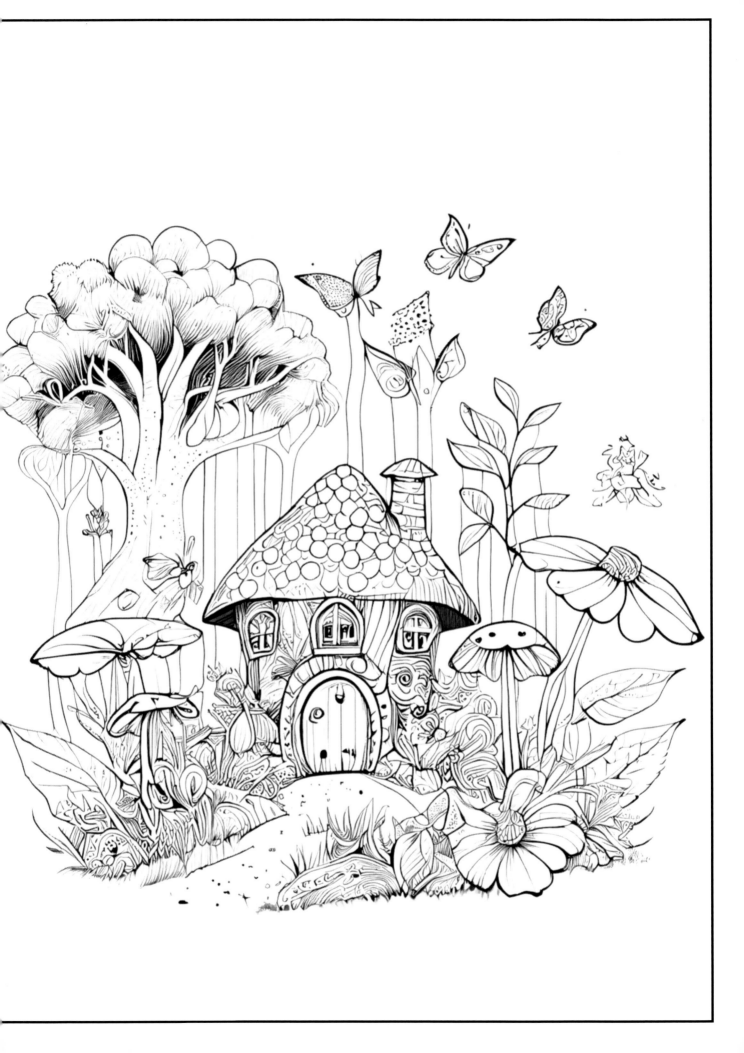

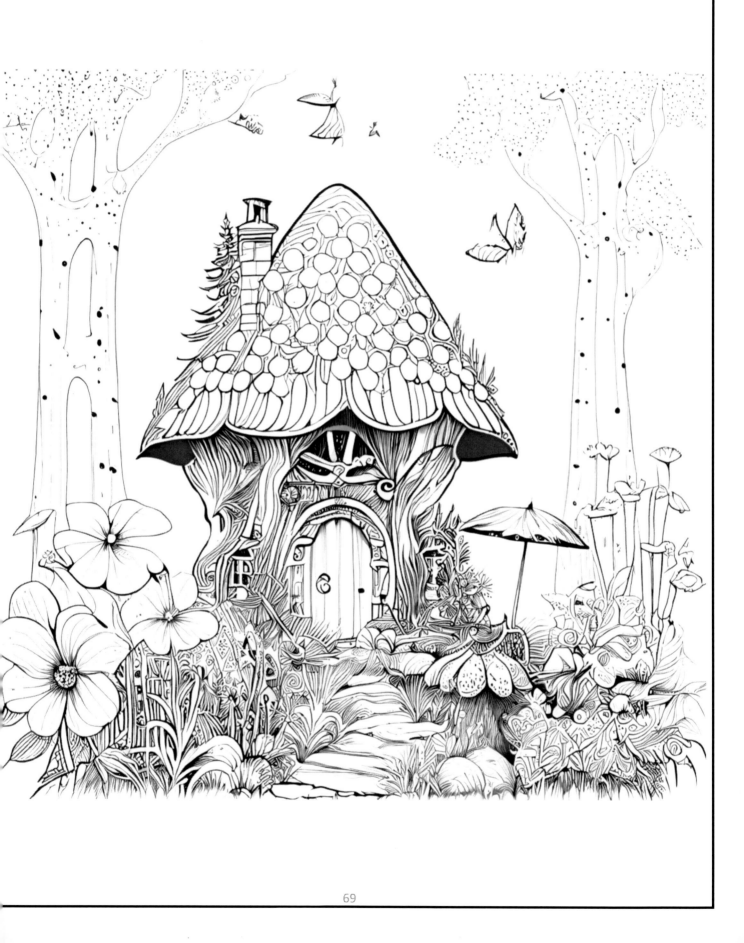

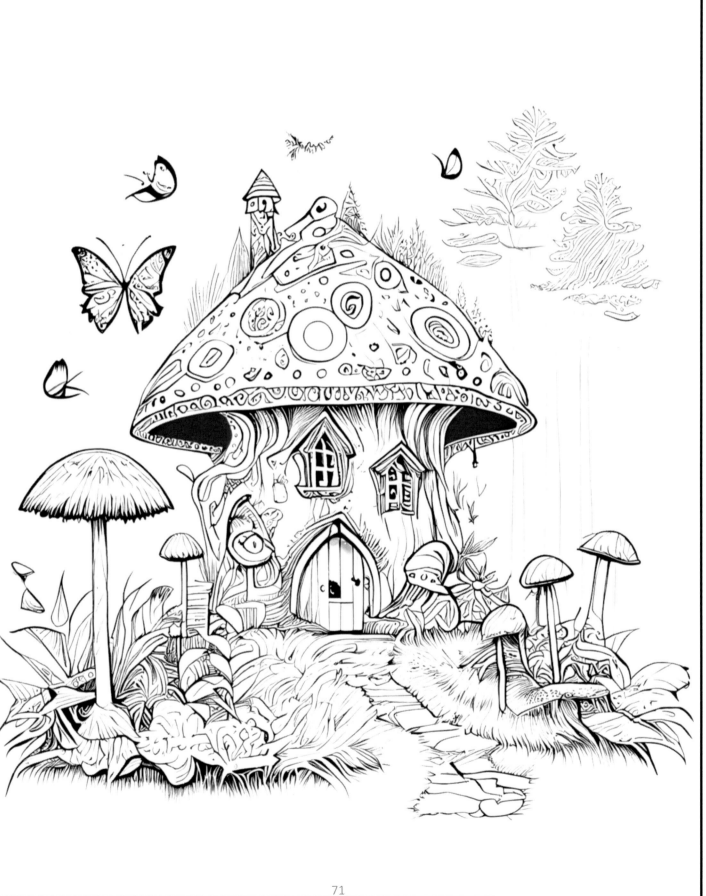

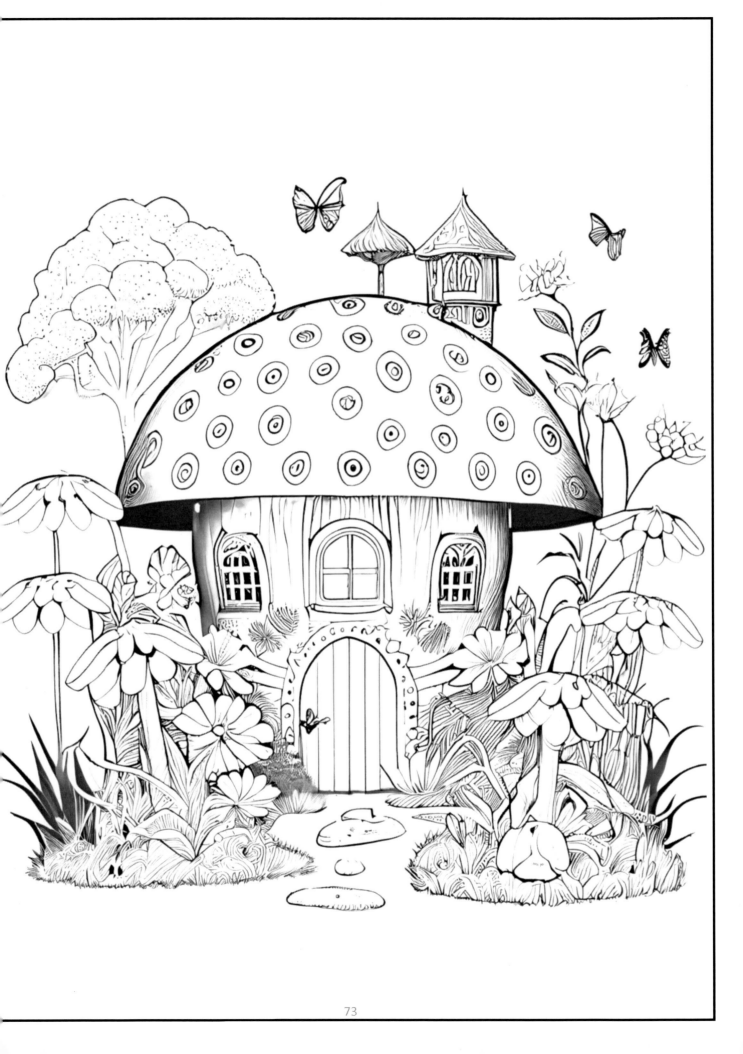

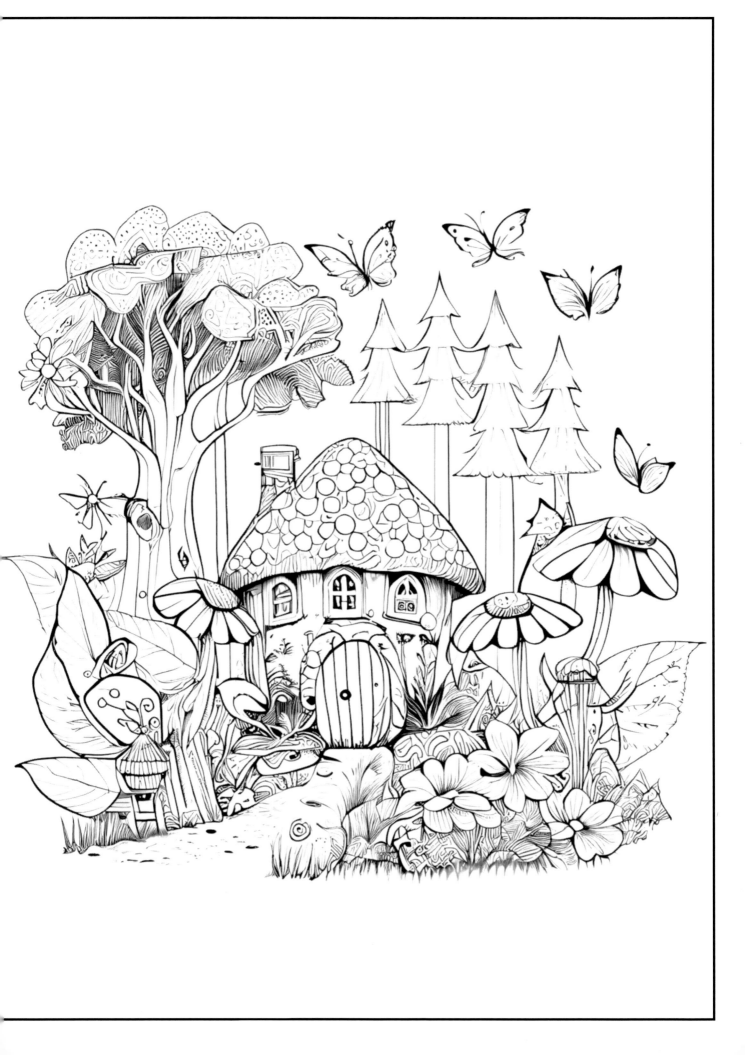

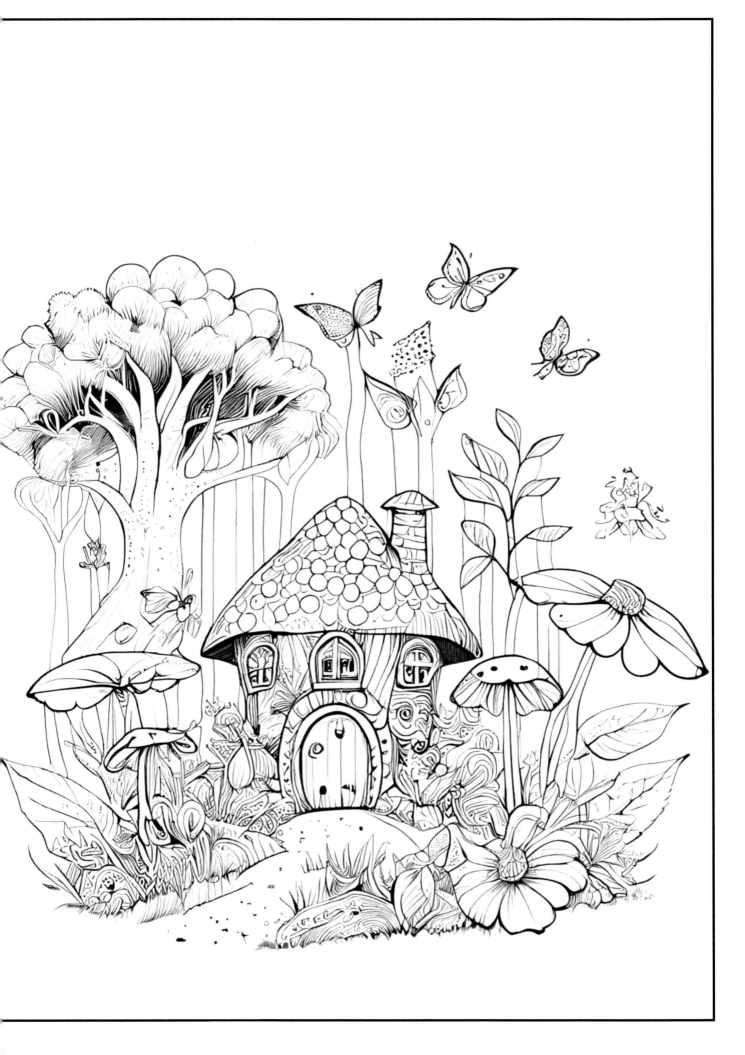

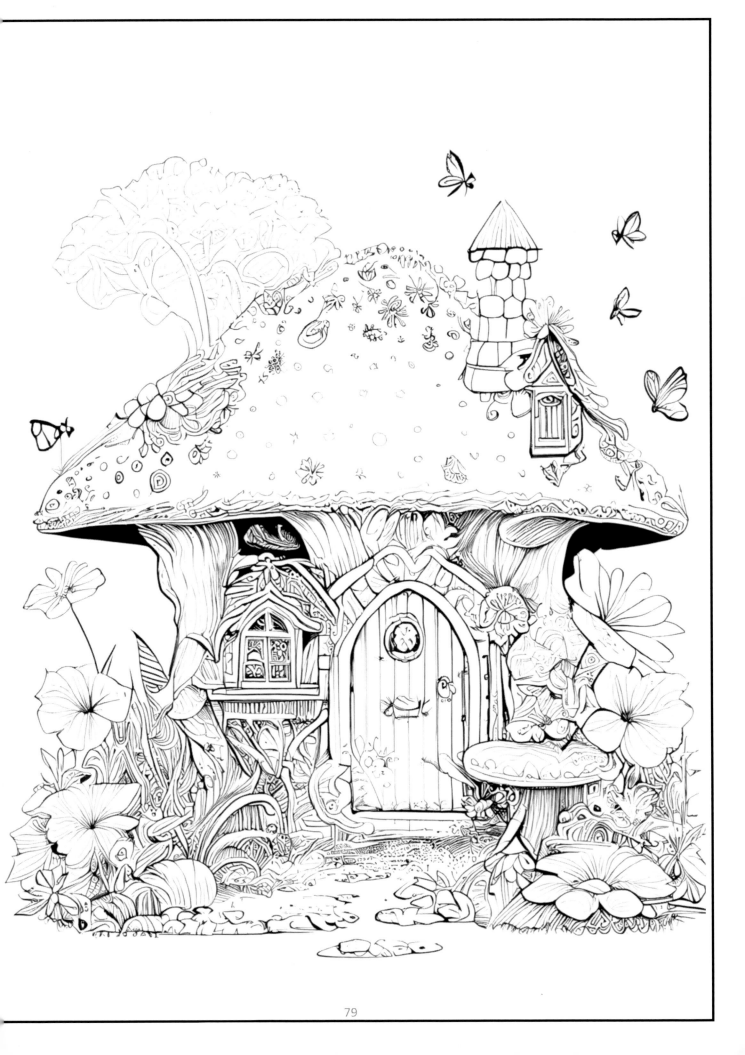

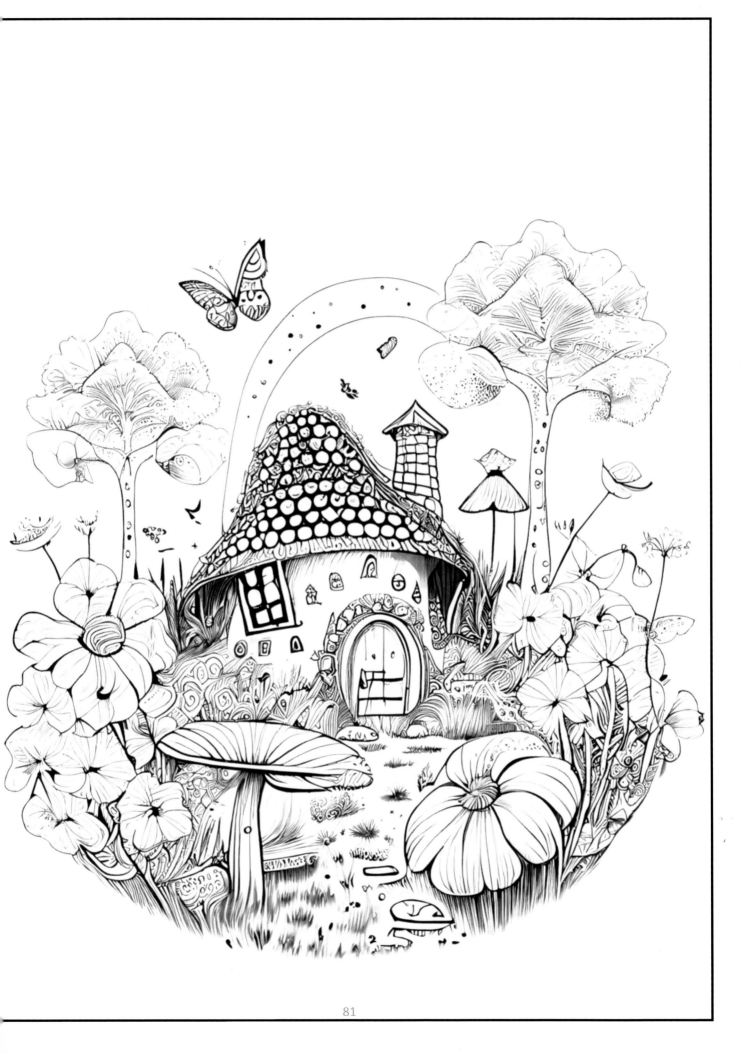

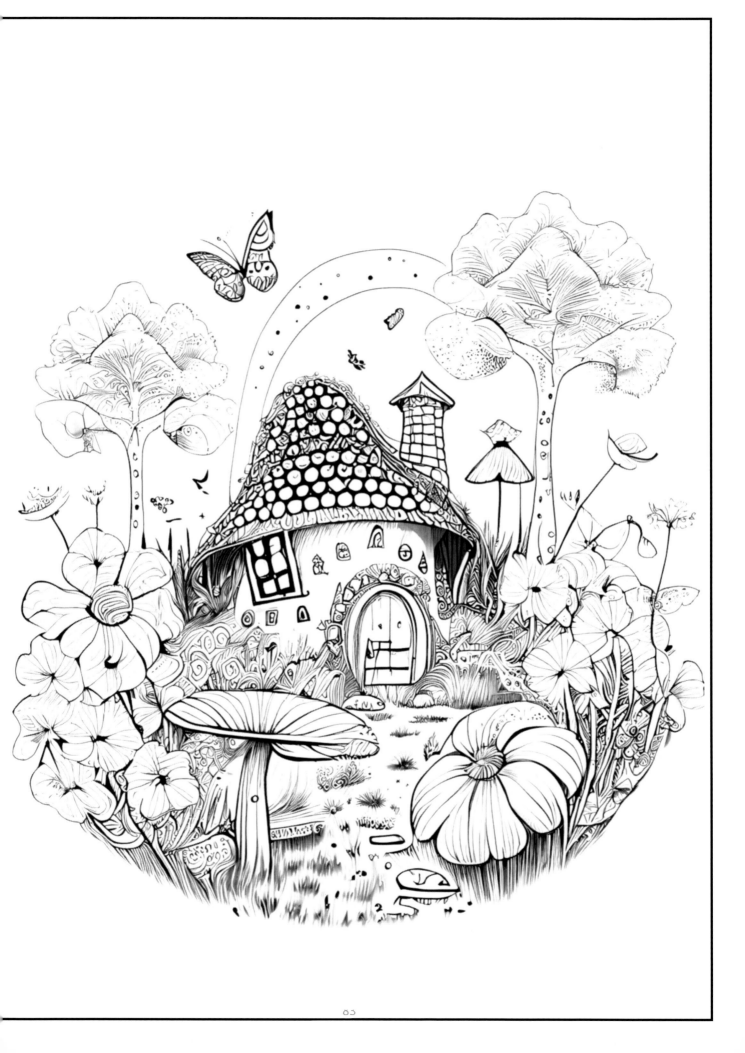

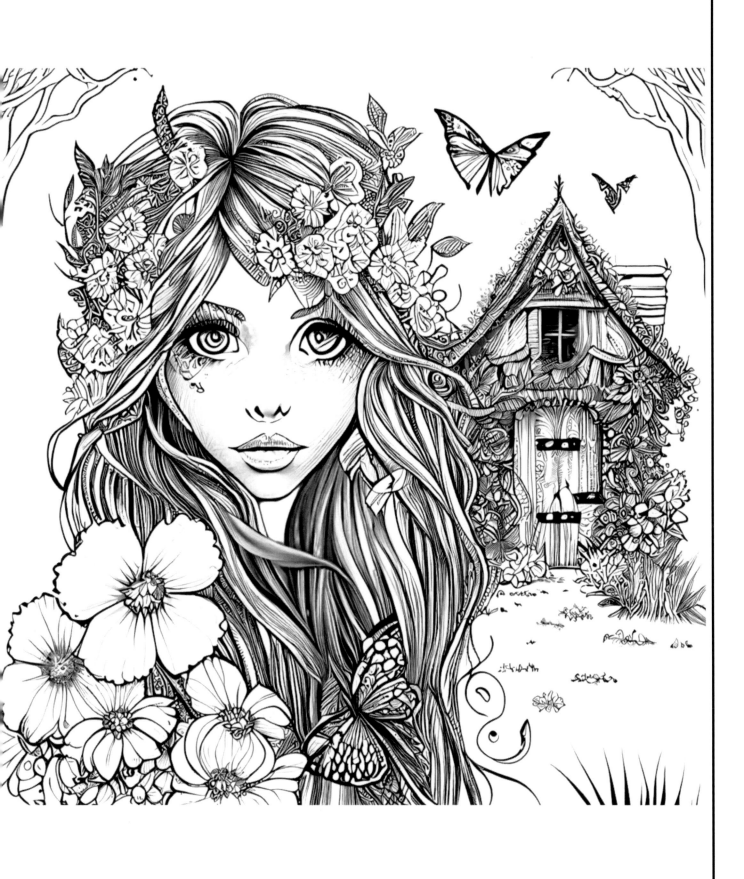

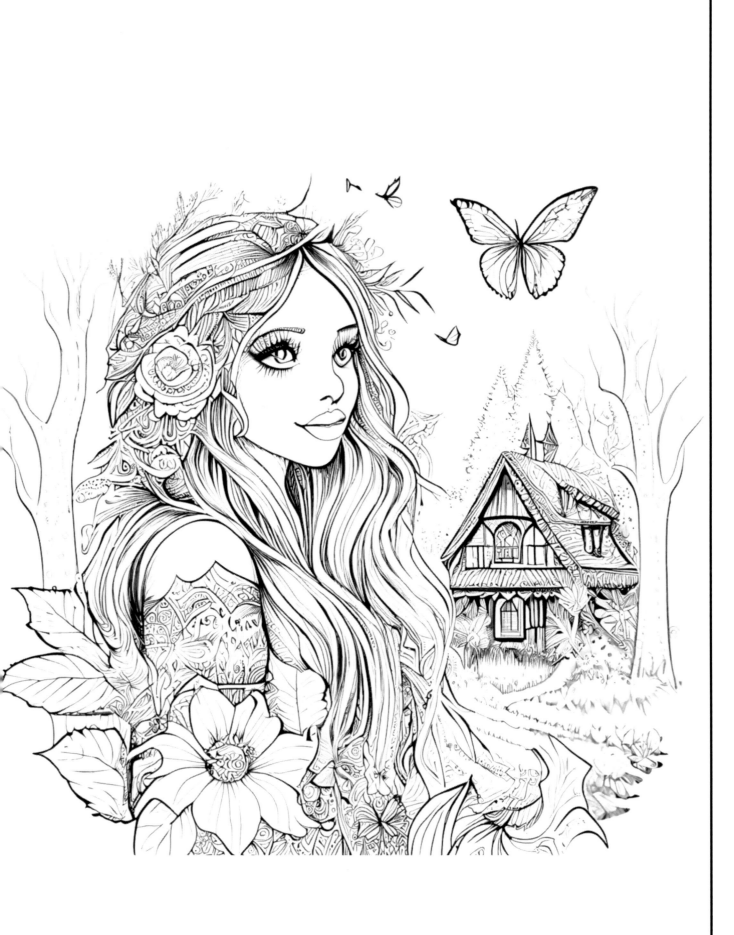

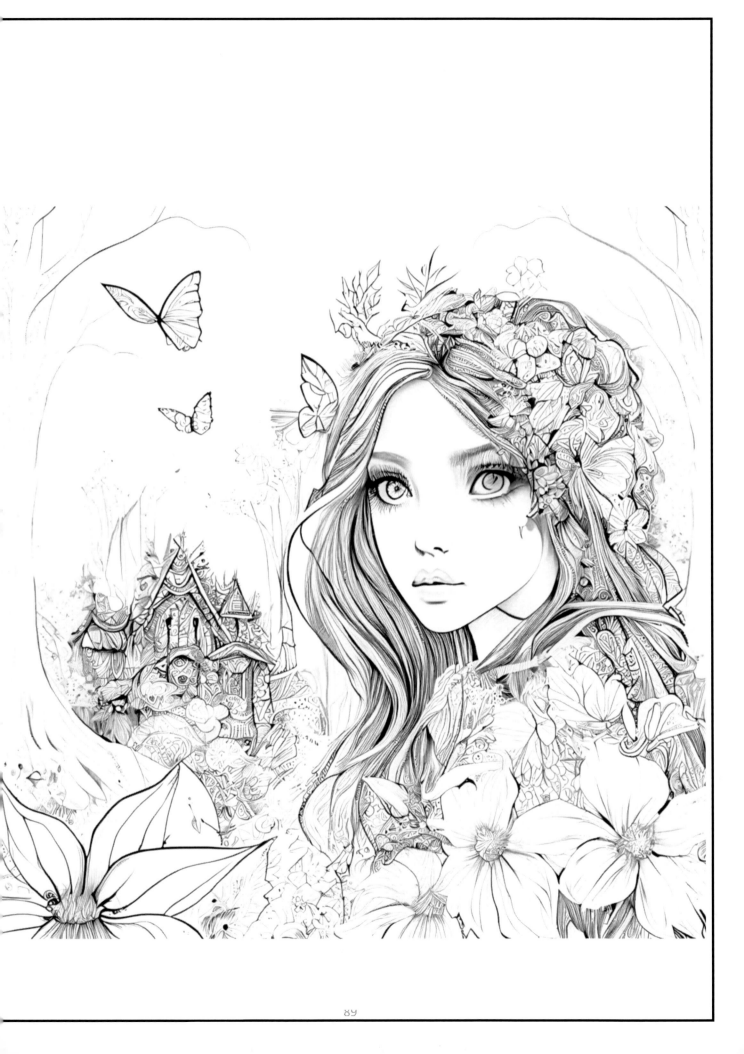

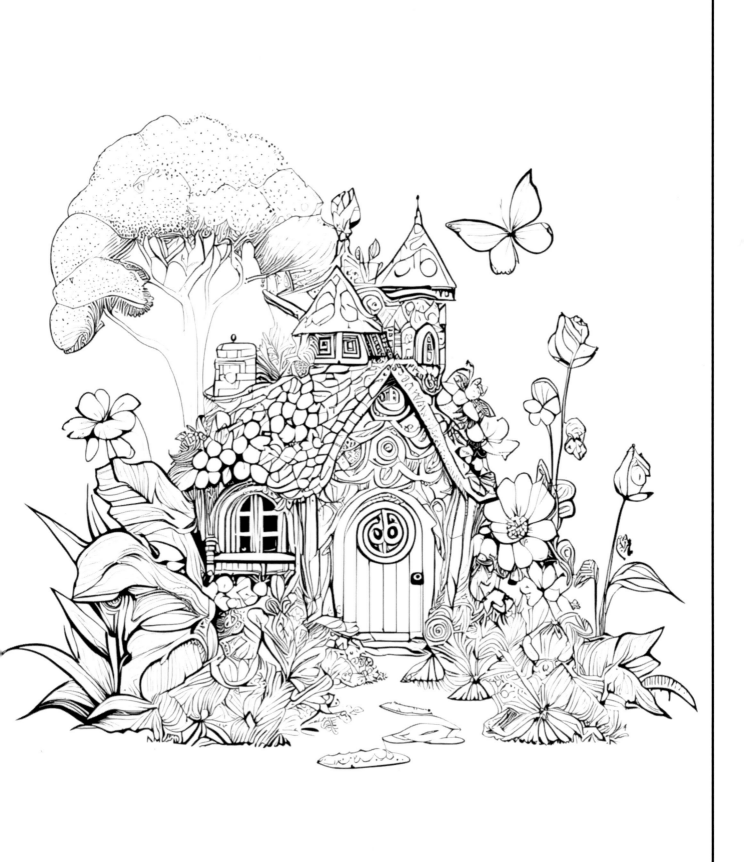

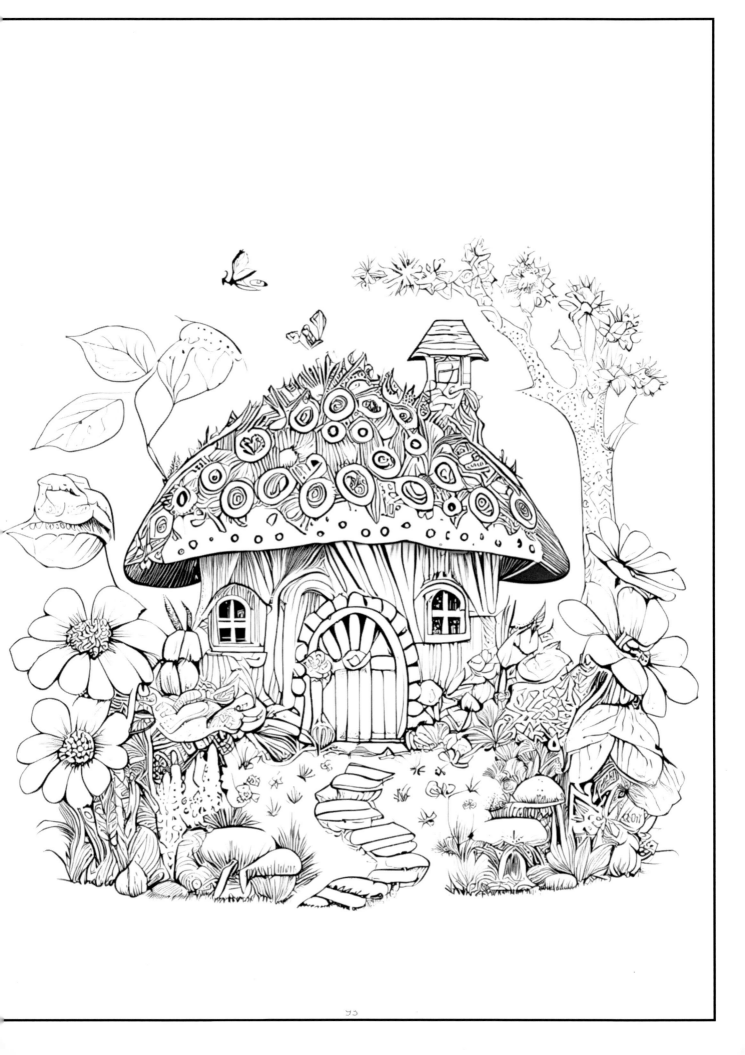

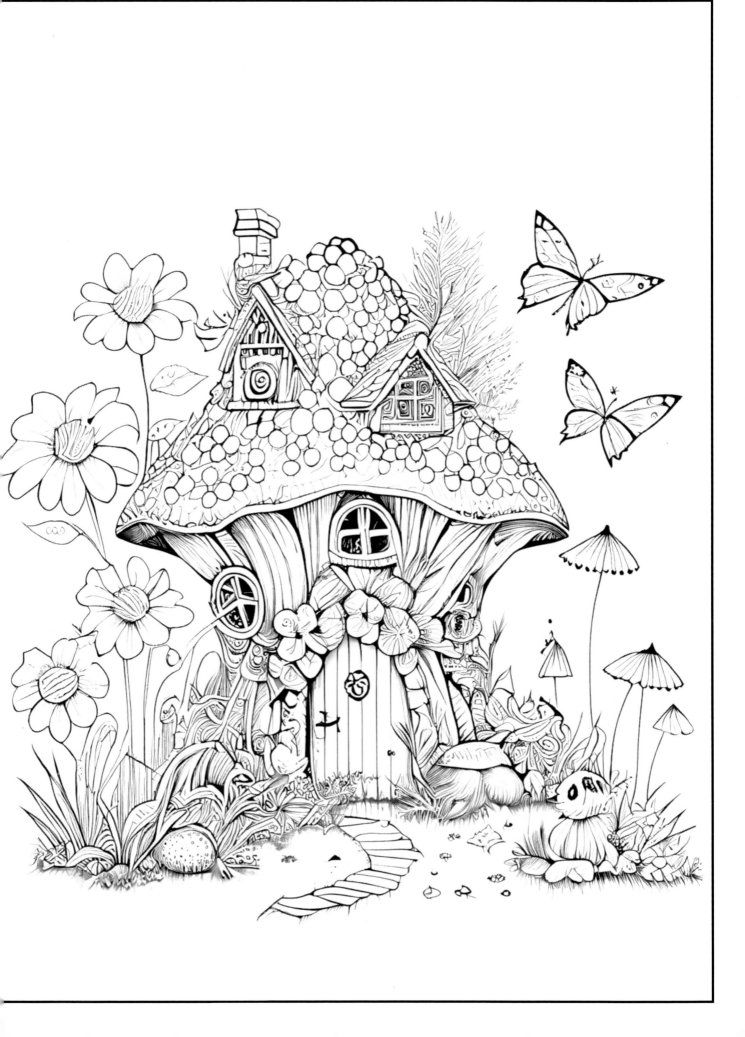

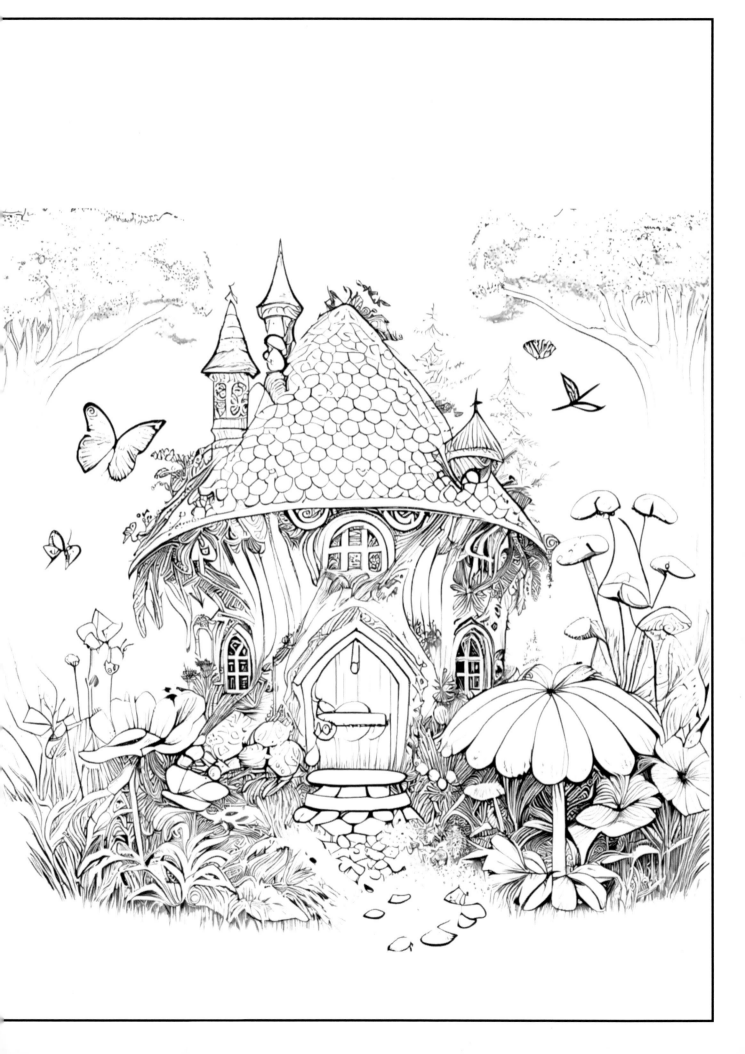

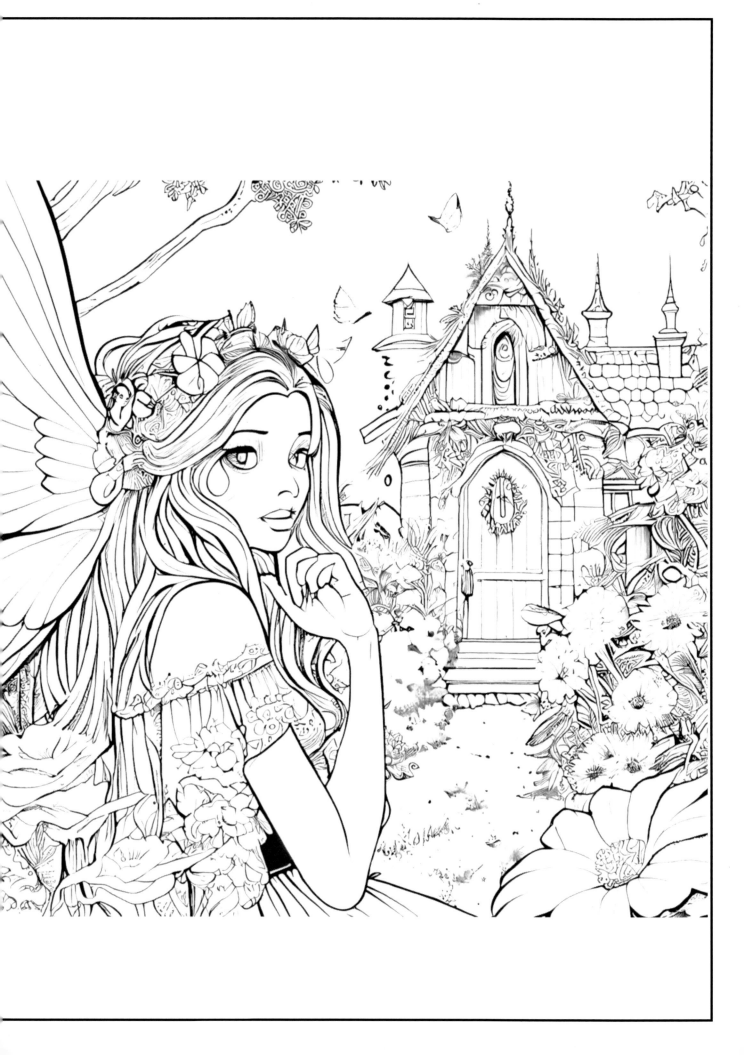

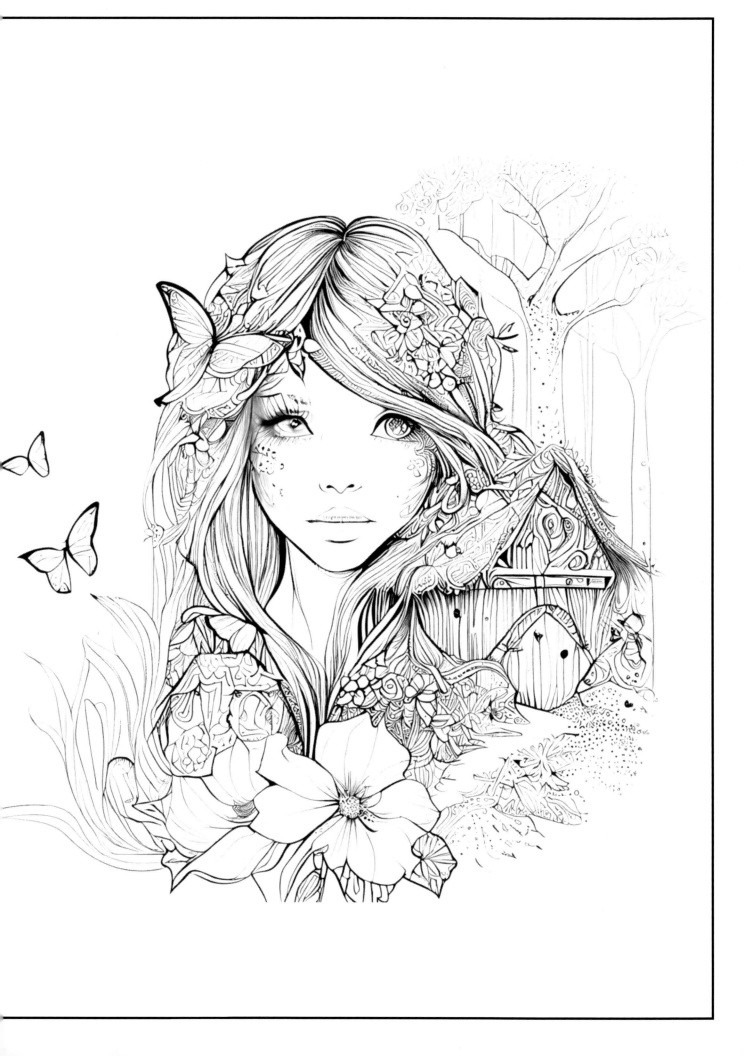